To My Fearless Visionary Friend

Susan

From: Mary & Holy

With Love & Blessings

On this date and in this location:

May 2013

Act Today Event

FEARLESS WOMEN

VISIONS OF A NEW WORLD

PHOTOGRAPHY BY MARY ANN HALPIN

FOREWORD BY MARY MORRISSEY

STORY EDITORS
LINDA GABRIEL AND MARSHA MERCANT

FEARLESS WOMEN PUBLISHING · LOS ANGELES

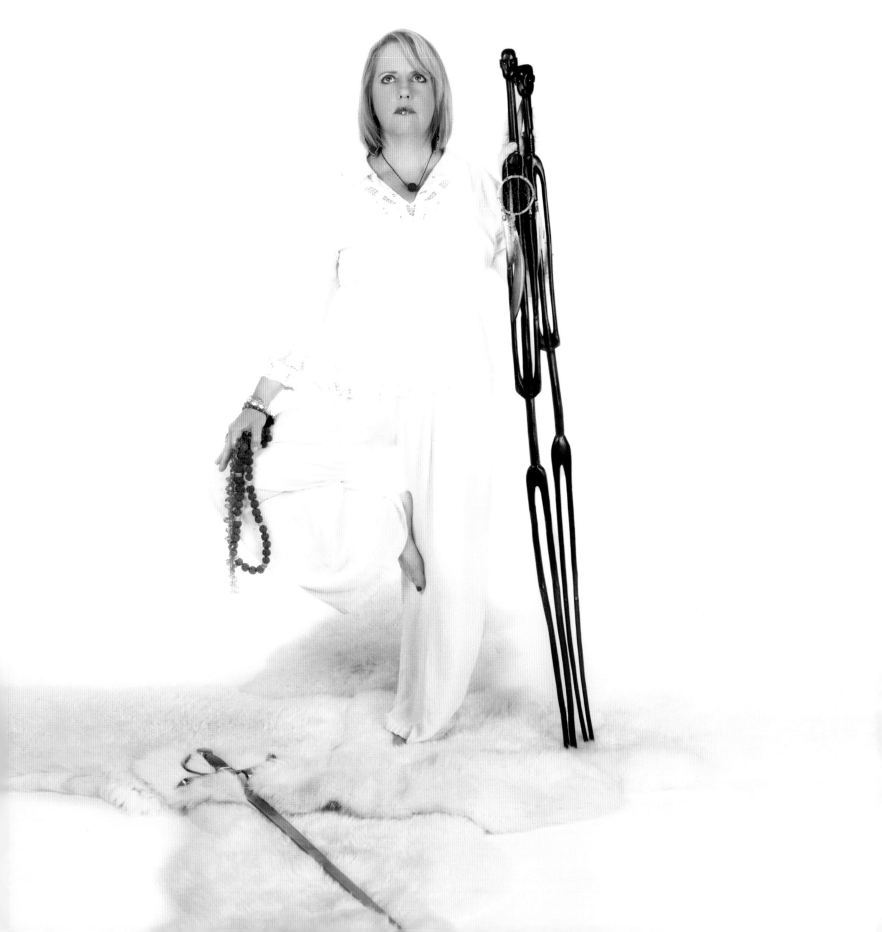

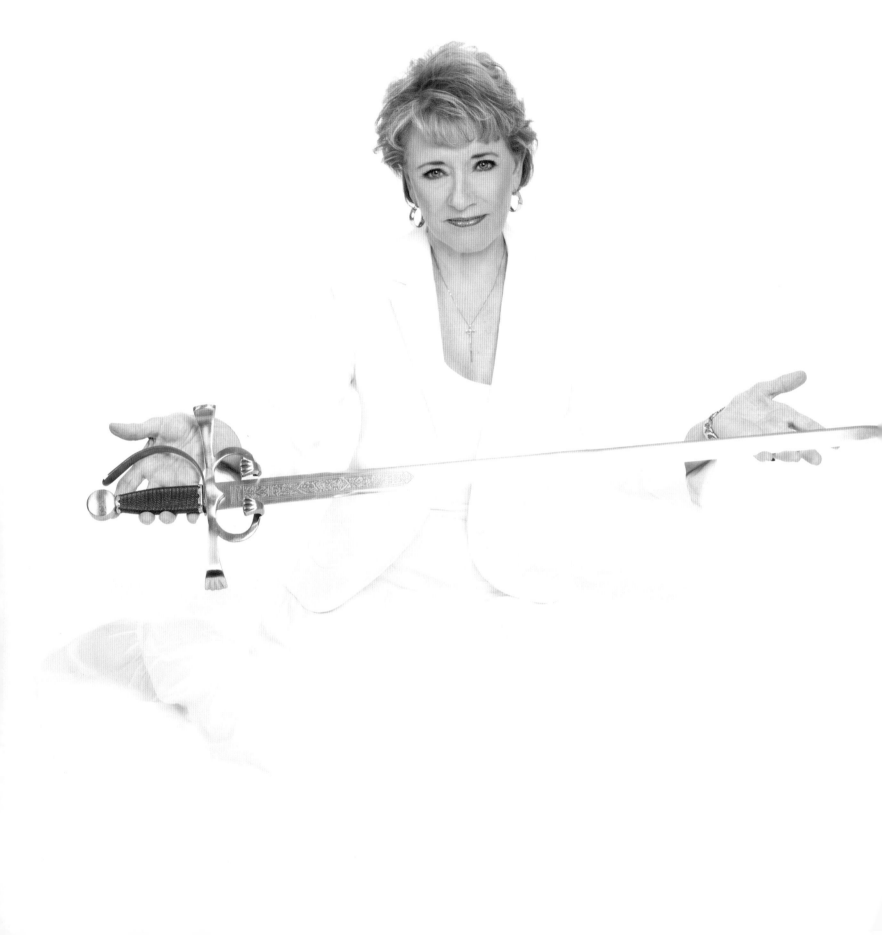

FOREWORD

BY MARY MORRISSEY

You are holding an amazing book in your hands right now. This book has the potential to inspire you, but even more, to introduce you to "a way of being" that will not only open you to more aliveness but, just perhaps, change your world.

When we were little children we had full range of our capacity to imagine anything we wanted. We might have imagined being a ballerina, an astronaut, a teacher, a nurse, a doctor, a scientist, a mother, or, or . . . OR??

Then we were, most likely, introduced to a learning system that taught us to "Stop daydreaming" and "Pay attention." Our capacity to deeply dream a life and a world that we REALLY wanted either fell asleep or was muted in "How will I ever be able to do that?"

The doubts and fears of daily life can easily win out over the hopes and dreams that often find little support in a world that insists on full maps and complete funding before one steps out the door to follow one's own hero's journey.

What if many, if not most of us, were handed the "wrong map" in our traditional learning? What if, all along, we really had what it took to tap into a source of strength, guidance and "know-how" that was found by "claiming a vision" we were totally passionate about?

What if the "Vision Itself" is the template of the map required for its fulfillment?

What would a woman, really awake to her potential, imagine for her world, so in need of transformation as the world in which we find ourselves now?

As you hold this book, you hold in your hands an entrance into an incredible opportunity. You are about to meet some amazing women. Each woman has found that her vision can be more powerful than any fear and stronger than any circumstance. Each woman has found a way to go forward in the absence of certainty. She has found a way to have, believe in, and act upon a vision that is beyond what her circumstance dictates or her history predicts.

As you meet each woman in this book, you will see a picture of her as she holds a sword. When you see the sword, please let it represent "The Sword of Truth." The Sword of Truth cuts away the seeming obstacles, so a greater vision can come truly into time and space.

For each of these women has found that there is a Truth, which she holds within herself. This Truth is not only an incredible Vision, but this Truth also gives her access to a power great enough to serve and bring about her Vision.

Guess what? You, too, can be a Fearless Woman who holds the Sword of Truth. A Fearless Woman is not a woman who never feels fear; she is a woman who, again and again, refuses to let her fear win out over her passionate vision. You really can be a woman who envisions a new world for yourself, your family, and our planet.

As you hold this precious chalice of a book, you hold both a beautiful physical volume, and you hold the Holy Grail of an opportunity, as a woman in the 21st Century, to co-create a life and a world worthy of your dreams, your projects, your children, and your grandchildren and theirs.

So, dear reader, you are now about to read these stories of women like yourself. You can find a bit or a piece of your sacred self on every page. Pay attention and you can glean a step or an idea to develop, which will forward your vision of the life and the world you would truly love.

I am so very grateful to Mary Ann Halpin for her amazing vision that is bringing us together in this beautiful project.

CONTENTS

Published in 2012 by Fearless Women Publishing
P.O. Box 6176
Pine Mountain Club, California 93222
323-874-8500
www.fearlesswomenglobal.com
www.maryannhalpin.com

ISBN: 978-0-9851143-0-5
Design: Peter Green Design, Glendale, CA
Story Editors: Linda Gabriel and Marsha Mercant

Printed in South Korea

Photograph opposite Title Page: Teresa Surya Ma McKee
Photograph opposite Table of Contents: From left to right; Tamara Archer, Paige Bearce-Beery, Belanie Dishong, Jolin Halstead

FEARLESS ACKNOWLEDGEMENTS

It takes a global village to create a project with a big vision! My heartfelt thanks for all the fabulous fearless women who invested in this project, found sponsors and became part of the Fearless Women Tribe. Thank you for your trust and support in the creation of this project. Thank you for traveling to all parts of the country to have your Fearless Portrait taken. Thank you for digging down into your soul to find the words to gift to the reader and share your personal fearless stories and visions. You are all true inspirations! I am honored to call you my Fearless Sisters!

A very special thank you to Lieutenant Colonel (Ret.) Karen Mertes, our cover girl, who bid so fearlessly on the auction to win the coveted place on our cover. You are a fabulous example of a fearless woman and I am proud to have you grace the cover of the book.

Another thank you to our six back cover girls, Kimbra Ness, Teresa Surya Ma McKee, Jean Carpenter-Backus, Nicole Jackson Jones, Rosemary McDowell and Tamara Archer, who gave their most fearless fiercest bids to win the six spots on the back of the book. We are happy that fifty percent will go to your favorite charities.

Thank you to our magical editor/storytellers for your talent in wrangling words. Linda Gabriel and Marsha Mercant, you fearlessly helped all the women dig deep into their hearts to tell their fearless stories. I am so grateful for your commitment to this book and your creative work. To Betty Liedtke for being another set of eyes and being our human "spell check."

My heartfelt thank you for the inspirational foreword written by Mary Morrissey. Your magical words of wisdom are breathtaking and I am eternally grateful for your fearless contribution. You made me cry when you first read your words to me!

I photographed women in Los Angeles, Austin, Minneapolis, Tampa and Boston. We are truly blessed with amazing professionals who assisted, supported and contributed their time and talent to help get this book done. We are so grateful to all of them:

Los Angeles Studio & Production Team

Michele Basler–Assistant to Mary Ann Halpin
Phyllis Botti-Project/Office Manager
Linda Gabriel–Editor, Los Angeles
Marsha Mercant–Editor, New York
Betty Liedtke–Word Smith, Minneapolis
Peter Green Design–Book Design
Dawn Green–Peter Green Design
Tim Sims–Peter Green Design
Nicole Bolin–Makeup/hair artist
Karolinka Ratajczak–Retouching
Marty Bruins–Retouching
Matt Maxwell–Videographer
Nadia Romanov–Social media
Rebecca Metz–Website design/
 Social media, Minneapolis
Gil Alan–Website design

Sandy Shepard, Esquire–legal goddess

Jamie Sheldon–Just Trademarks

Liria Mercini–Much needed friendship
and support

Susan Rosenthal–Branding and fearless vision for
Fearless Women Global

Linda Hollander–Sponsorships

Mary Erickson–Event planner for
Fearless Women LA Event

Bridgette Crull–U Lucky Girl,
PR & Marketing, Dallas

Ginny Esterle, My Mom–for her fearless support

Jim, John & Richard Esterle —my brothers—and the
rest of my Fearless Family – for your support and love.

Austin Team

Korey Howell Photography

Zach Howell–Assistant

Sara Domi–Makeup/Hair artist

Jean and Andrew Backus–hosting us at their home/
hosting Fearless Women Event at Hyatt

Patti DeNucci–speaker/Fearless Women Event

Beth Broderick–speaker/celebrity/Fearless Women Event

Dennis Bailey

Minneapolis Team

Orin and Abby Rutchick–Minneapolis; MPLS Photo Center

Rod and Stephanie Oman–studio location finding/support

Mariah Herndon–Makeup/Hair artist–Kasia Organic Salon

Sean Patrick–Photo Assistant

Mary Jo and Frank Sherwood–hosting us at their home
for our stay/Fearless Women Event

The Women's Club of Minneapolis–Fearless Women Event

Tampa Bay Team

Monique–Makeup/Hair artist

Donna Green Photography–Photo assistant and
equipment rental

Leslie Belcher Huston, Linda Conley–Fearless Women
Event, Renaissance Hotel, Tampa Bay

John Huston–Reminiscing expert

Lena Hunt–Celebritize You

Boston Team

Janet Powers, Diva Toolbox–Hosting us at the Diva
Toolbox Women's Conference

Lisa Roche–Makeup/Hair artist

Dan Orlow–Photo Assistant

Pine Mountain Club, California

Ginger Martin

Charlie Hall–Musical arrangements, producer, musician

Patric Hedlund

Jason Nedelman–Base Camp, for the fundraiser

Stacey Havener

Wyatt Underwood–Art & Wine Gallery Cafe

Ruth Handy–Jizo Peace Center, contribution to the project

Marcy Axness–for help with SunJay and the Martin Sister's story

Featured Children

Jolin Halstead portrait

Garret and Conner Sullivan

Chidera Abaelu

Maddy Miller

Leslie Orazco

The Mommy Docs

Baby Samuel Unthank

Women in Circle, Tracy Jo Hamilton

 Deborah Yungner

 Judge Pamela Alexander

 Josie Milan

 CJ Shepherd

 Lily

Contributing Photographers

Korey Howell Photography, Austin, Texas

 Korey Howell, Photograph of Jean Carpenter Backus

 www.koreyhowell.com

The Imagery Portrait Photography, Minneapolis, MN

 Rod Oman, Photograph of Tabitha Kyambadde

 www.theimagery.net

Music CD

A special thank you to Jim Studer–Twin Suns Music, Los Angeles. Mastering and mixing the CD.

All the singers and songwriters who are profiled in the back on the music page, again....Thank you!

As in so many projects, it takes so many people to create a successful endeavor. For anyone that we left out, we thank you and hope you know how grateful we are for your support!

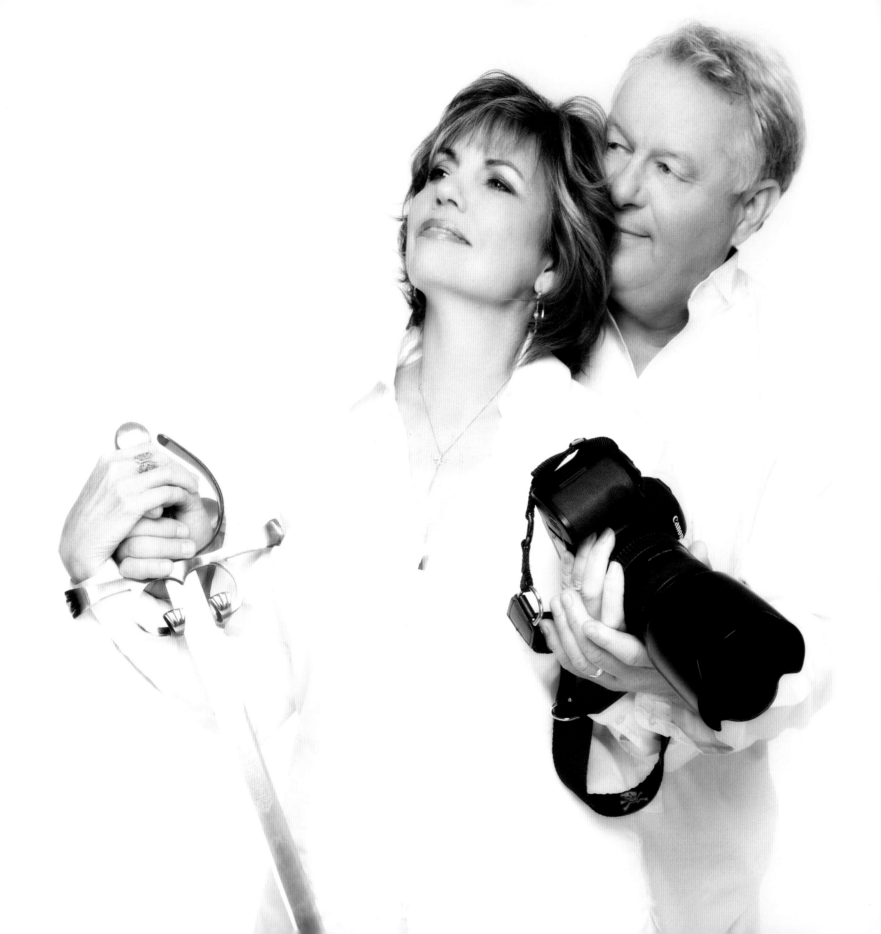

INTRODUCTION

As 2010 came to a close, I had the vision to create a third book in the Fearless Women series. I saw women wearing white, on a white background, holding an object that symbolized their vision for a new and better world.

There could be no doubt that a shift was happening in the world. On the surface, it didn't look like a pretty one… wars, famine, earthquakes, governments collapsing and fear, lots and lots of fear. The Mayan calendar ends with 2012. That could mean the end of the world, or there was a new and better world coming. I believe the latter.

This year, 2012, marks my 60th year on the planet. It is the beginning of my third stage of life, my wisdom years. I feel a fierce calling to gather women together to share their vision stories, to ask the questions that I live with every day, "What does it mean to be a fearless visionary woman?" and "How can I help create a better world?"

I can be a cart-before-the-horse kind of gal, conjuring brilliant ideas that I jump into with wild abandon. Admittedly, sometimes before I know if that cart will take its rightful place behind the horse! But in spite of, or maybe because of my exuberance, I am always rewarded with richly satisfying experiences. The journey last year to gather the women for this book, was one of those experiences. We traveled to four cities, Austin, Minneapolis, Tampa and Boston, for Fearless Women Events where we photographed local women as well as others who flew into each city.

One of those remarkable journeys was that of Rose Pagonis, who wanted to be photographed with her mom so badly that she drove for nineteen hours from Chicago to Tampa. Rose's mom has Alzheimer's and is forbidden by her doctors to fly. But Rose had a vision. She wanted to honor her mom by having her appear in the book and wouldn't let anything stop her from achieving that vision.

The stories in this book are not presented as solutions to how the world should be, but rather as a heart cry of our desire to clear the confusion and get the answers we seek to a new and better world. To live authentically, we must each engage in the journey that speaks to us, as an inner seeker, an activist or both. I don't profess to be a leader, but merely another participant in this sometimes perplexing dialogue.

In my reality vision, I am truly blessed with a soul life partner who is willing to dance the fearless dance. Joe supports my dreams and visions and works with me to achieve my goals. He is my confidant, chef, schlepper, sherpa, computer tech and hunk of burnin' love. Knowing he's got my back is more than a fearless goddess could ask for.

My heart is filled with eternal gratitude for being gifted this fearless women journey. Even with all the challenges and seemingly insurmountable situations, I feel blessed to be walking this path. With a sword, sometimes serving as a cane to keep me from falling, I move through the adversities of life, my head facing the future, my heart filled with courage and my eye on the vision; a vision for a new and better world. The fearless journey continues!

Yours in Fearless Vision,

Mary Ann Halpin

P.S. I invite you to pull out the CD attached to the inside back cover with songs contributed by fearless, fabulous women singers, songwriters and musicians. Fire up your stereo, get yourself a cup of coffee, tea or wine, and indulge yourself in this fearless multi-sensorial experience of viewing the portraits, journeying through the stories while listening to the inspirational music.

Enjoy!

FORBES RILEY AND HER DAUGHTER MAKENNA

As a health and fitness expert I believe that Gandhi's statement, "The future depends on what we do in the present," relates to taking ownership and daily responsibility for our most precious possession – our body.

We have the choice to change the world everyday by changing how we live in it. Simple ideas such as choosing organically grown food, not indulging in processed "junk food," treasuring the environment and speaking words that serve to inspire others can have such a powerful impact.

As a motivational speaker, author, TV host and actress, I use my own story of struggles and triumphs to encourage women to be heard, take a stand, believe in themselves and get their bodies moving.

To that end, I have created the fitness product SpinGym (It's what I am holding in the photo!) that encourages getting in a quick "no excuse" workout anytime, anywhere. When your blood flows, your heart beats, and your muscles fire, you know you're alive and energized.

In my career, I was fortunate enough to spend eight years standing next to the "Godfather of Fitness," Jack LaLanne, who preached, "If man made it, don't eat it." He helped me understand the value of real food, daily exercise, and a commitment to a way of life that inspires others.

At 42 years of age I became the proud mom of healthy 7-pound twins. My 8-year-old daughter Makenna, pictured with me, is fast becoming a fierce example of all my teachings, hopes and dreams. She reminds me daily of the joy of unconditional love and of the responsibility that I have to be a role model.

My hope is that when her twin brother Ryker sees us in this book, he will understand how important it is for the women in his life to be brave, take a stand and hold up the sword for so many who cannot.

Motherhood has cemented the goal in my heart to work hard to make this world a place worthy for our children. To allow innocence, wonder and magic to flourish. We get to bring up the next generation, but the healing must begin within. It takes courage to dream and it demands us to be fearless to achieve those dreams.

Fearless Vision:

You only live once, but if you do it right, once is enough.

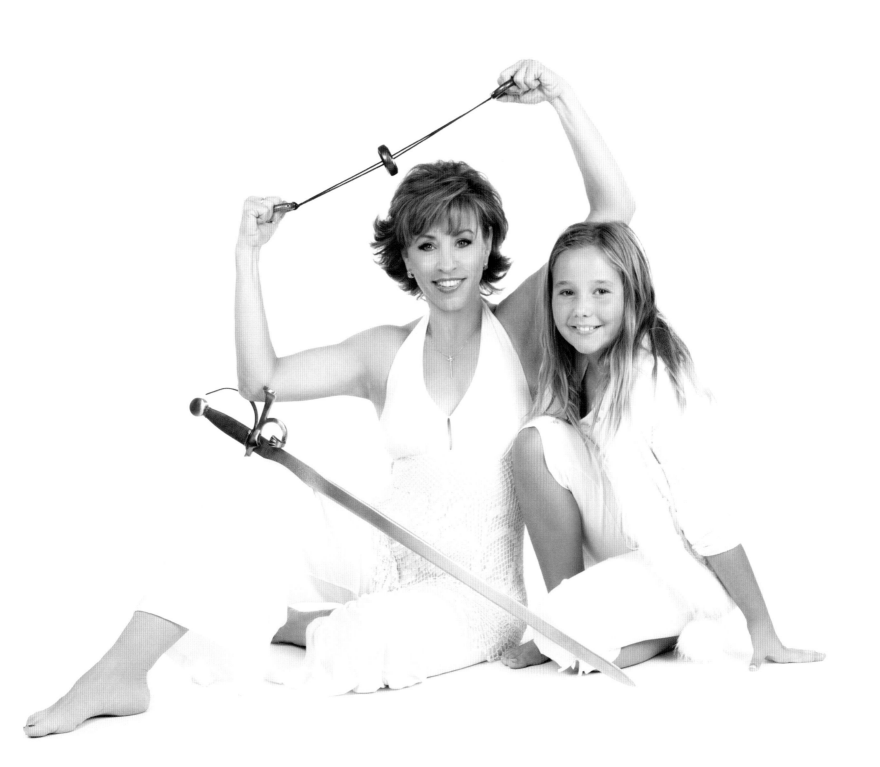

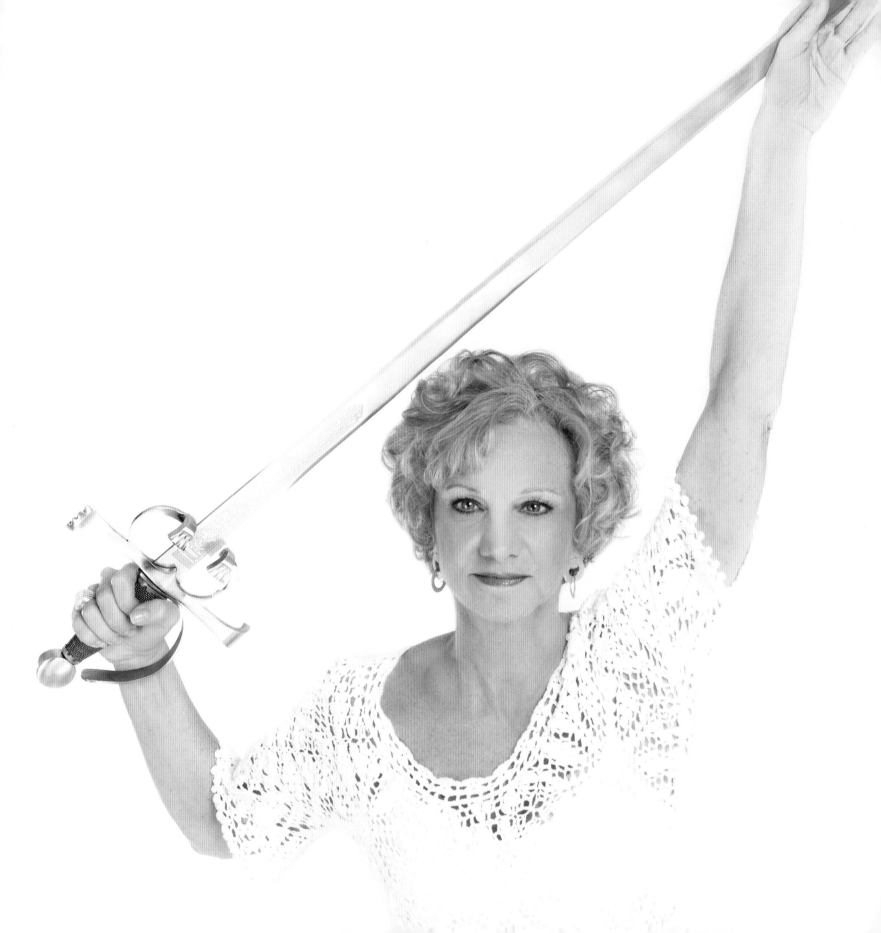

SUSAN ROSENTHAL

My quest begins as an innocent nine-year-old. Why am I here? What is the purpose of my life? These questions compel me. I explore my spirituality and nurture it in earnest. Summers in the Maine woods ground me. My love of learning leads to top grades and honors. Living, studying and working overseas become a focus. I try on new beliefs and enjoy the resultant growth.

Youthful ambition translates into a strong desire to become a business manager. With MBA from Kellogg in hand, I leap onto the corporate fast track. Crisscrossing the world, I direct operations, launch strategies and market products with Colgate-Palmolive, Citigroup, Ocean Spray, ATT Wireless and several entrepreneurial ventures. My focus is on reaching the top. I enjoy successes as Senior Vice-President of Strategy, Chief Marketing Officer, Chief Operating Officer and CEO.

September 11, 2001, the planes hit the World Trade Center. Mom dies two days later. I return home to New York City, my heart filled with grief. Simultaneously, my executive position is eliminated in a corporate merger. Identity markers are gone.

I renew myself in retreats, spiritual teachers, and women's communities. In 2008, I create the Your Power To Heal™ Conference at St. John's University, two blocks from the former World Trade Center. Dedicated to Mom, it empowers people to take charge of their health, particularly when doctors are discouraging. Ten speakers deliver lectures and workshops on self-healing across physical, mental, emotional and spiritual methodologies.

Nineteen months later, I lose sight in one eye. With no clear diagnosis and doctors' talk of disability and worst-case scenario, I am called to make a choice; relinquish to those doctors or partner with my own body's ability to heal. I create a healing path and choose to celebrate my life with or without sight. In time, my sight returns. I learn to view loss as both a messenger and a teacher. Apparent tragedy morphs into an opportunity for growth.

Today, thriving on my own as a businesswoman, consultant and speaker, I motivate others to find their own compass. That nine-year-old has lived Carl Jung's truth: "Who looks outside, dreams. Who looks inside, awakens." I am grateful for this journey and the opportunity to guide others in realizing their greatness.

Fearless Vision:

Who I CHOOSE to be defines me. Embracing this, I create my life and opportunities. I envision a loving world where all awaken to their essence and power.

BELANIE DISHONG

The floor is so very cold. The pain in my stomach is excruciating. What is going on? I am so sick. Eyes still closed, trying hard to gather my thoughts. The ever-dooming sadness washes over me once again. OMG, it didn't work, it didn't work! Now, I not only have to continue facing what was happening in my world before I took the pills....now, I must also face the world with what I have tried...and failed...to do.

I can list all the "justifiable" reasons; my prince is leaving me, my home is headed to foreclosure, I lost my job just a few weeks before because I wouldn't relocate knowing my husband wouldn't move. Facts, yes, but it was the victim in me that led me to the drama and the overwhelming fear. I am in the deepest black hole of my life.

Three children to raise and feeling in that moment, that everything was gone. It took time. Lots of time. But eventually it was as if a bright light had been cast into that deep black hole. It became clear that the person I once knew myself to be had died and I was ready to take on a new precious life.

Now, I teach others to do the same. When people change their thinking, crises are avoided and dreams are realized. Change your thinking, change your life, change the world! Since 1993 I have taught thousands of people from all walks of life how to move from fear to accomplishment, empowering families, businesses, and relationships.

My company, Live At Choice, LLC believes in paying it forward within our communities. We provide workshops for Deaf Hope Organization serving deaf women who are survivors of domestic violence and sexual abuse in Oakland and the San Francisco Bay Area. Additionally, we also gift workshops for Living Forward Alliance Organization (LFA), a non-profit organization for the education, self-development and mentorship of women who are incarcerated and serving time for drug and alcohol offenses in the Houston area.

Over the years my transformation was far greater than I could have imagined. From that dark day in 1985 to 1993 when I began conducting workshops, prayer, support, love, and encouragement from others led me to the life I have come to appreciate. I learned how to change my thinking and in doing so, help others transform their lives!

Fearless Vision:

Once my dream...now my vision, a world where all people live in joy and are present to the experience of love, leaving victim and fear behind to live victoriously!

BRANDY RAINEY AMSTEL

Sometimes it's difficult for me to comprehend just how I came to be sitting in a dirty, sweaty, makeshift tent participating in the infamous "Sedona Sweat Lodge," where three of my friends lost their lives and seventeen others were injured.

Ironically, the purpose of the event was to help us recognize and break through our limiting beliefs in order to take our lives to the next level. The leader encouraged us to override our fears and assured us we would not die.

I recognize that the choice to participate was always mine, but I also was not aware of all of the facts that day in the sweat lodge. Had I been, I would have made very different choices. In the end, it was acting on my intuition that saved my life.

Throughout my life there have been times when I've given away my power without even realizing it. How? By blindly trusting the government, doctors, pharmaceutical companies, spiritual leaders, and other authority figures. I now know how important it is to educate oneself and listen to one's inner wisdom.

To this end I've created Living Powerfully, a WebTV show that explores how people tend to give their power away, how to take their power back, how to make informed choices, and how to create a life by their own design.

Living Powerfully speaks about taking responsibility for the environment, the quality of the water we drink and the food we eat. We discuss image, dreams, authority, and ethics. We challenge people to ask questions that are empowering. Most importantly, we encourage people to follow their intuition.

My vision for a new world is one where people are awakened, transformed, and empowered to create a life that allows them to fulfill their purpose and dreams. I envision a world where we love and respect ourselves and one another, a world where we take care of our planet and all the creatures that live here with us.

I believe everything happens for a reason. When I share my story with the world, my mission is to awaken people to a part of life where they may not be listening. Instead of going through life pretending there is something outside of ourselves that is creating our experience, we can develop the courage to listen to our inner wisdom and make the most self-empowered choices for our lives.

Fearless Vision:

Be bold, be courageous, and stand for what you believe in. We all
have the power to make a difference.

Cherie B. Mathews

How is fearlessness born? Through adversity? Through no longer being willing to live with the status quo? By a calling that is greater than yourself? I say yes to all of the above!

At the age of 40, with no prior family history, I was diagnosed with breast cancer. After falling down the black hole of despair and fear, I became proactive, angry in fact, that this enemy would dare threaten my family.

My battle cries became, "Early detection saves lives!" and "Be fearless when it comes to your health!" Based on the research of my diagnosis, I chose to fight my disease with a double mastectomy. Not something you would imagine you'd fight for, but I wanted the cancer out of my body. After surgery, it was discovered that there was more cancer in the undiagnosed side than in the diagnosed side. Be proactive, research, ask questions!

I want to say, going in I was pretty brave, spurred on by the knowing that I would not leave my family motherless. But coming out, to the pain and realities of living with my new body, was another thing entirely.

After being chastised by my nurse for having the wrong clothes to go home in, I realized there was an opportunity to enlighten. I'd love to say that I jumped right into that mission, but the truth is that it took me ten years to even be able to talk about my breast cancer.

We moved to Austin, Texas, where I met many earth angels. They helped me to reflect and hold myself accountable to my gift of life. Through prayer, I realized that I couldn't help anyone being self-protective and quiet. So when I opened my mouth to eek out the words, "I had a double mastectomy," it wasn't to some new friends in the confines of my home, it was on TV! I walked away from that TV interview a changed woman, bold and courageous, ready to make a difference.

Being a natural problem solver, it made sense that I would create the Heal In Comfort Shirt, a recently patented garment that supports the physical journey of healing and the spiritual need for comfort and dignity during a challenging time.

I tell everyone, "Be Brave and Fight Like a Girl!" Don't' get stuck in your fear. See everything that happens in your life as a gift. Then you can take those gifts, step out and change the world.

Fearless Vision:

My new world vision is all people using their gifts to help others and our earth, to become a happier people and a healthier planet.

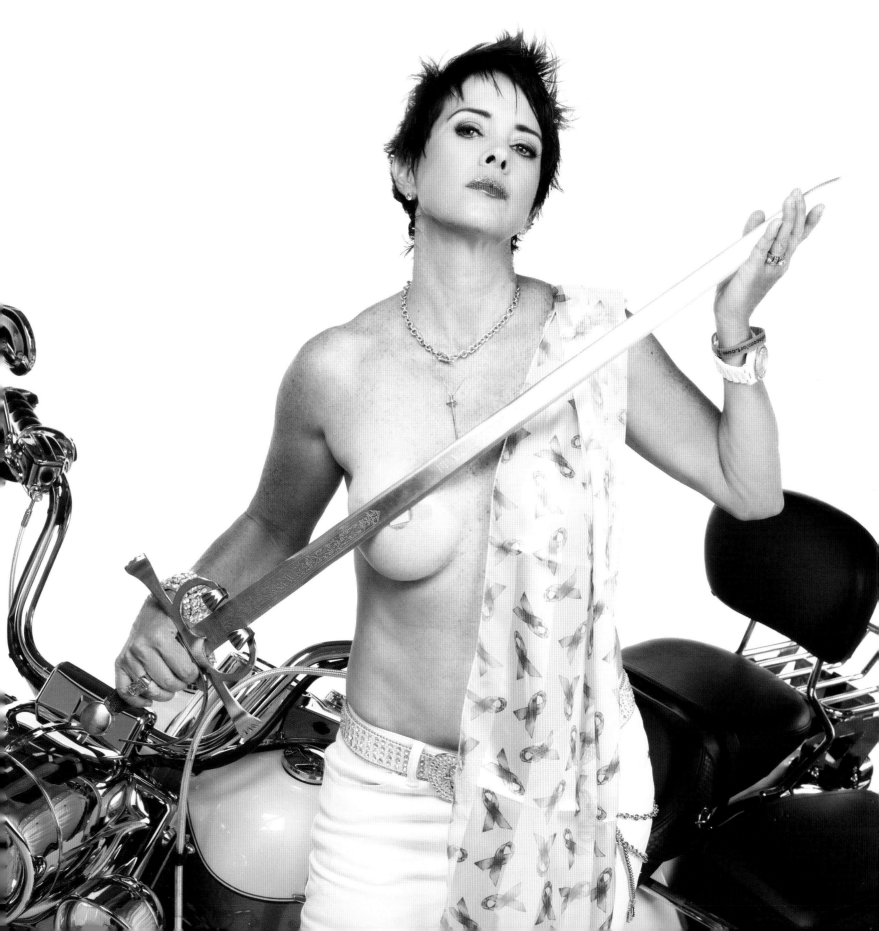

JANET GRACE NELSON

My journey of becoming a fearless woman has been one of knowing the power of Love and holding my vision for a full, joyous life. When I was a young fashion design college student, a motorcycle accident nearly took my life, leaving me with a broken back, collapsed lung and a shattered face. The long, arduous journey of healing my body, mind and spirit, of virtually putting Humpty Dumpty back together again, was guided by not only my deep faith, but also by the prayers and Love of family and friends.

Several years later, having created a garage-based jewelry design business that grew into a corporation serving thousands of stores and catalogs worldwide, my 22-year marriage had reached its completion. At that same time, there was a stirring in my soul to step up, to really make a difference, to help other women and children live a fuller life. With that, my daughter and I joined a mission group in South Africa with Horizons' International that sponsors orphans of AIDS. That life-changing experience led us to not only sponsoring many children, but also the opportunity to introduce others to the joy of getting involved and being of service to this great vision.

Answering the call to become a Spiritual Practitioner and Life Coach guided me to inspire passion and empower change in others through vision-driven programs, workshops and retreats. I encourage my clients to find a deeper understanding of themselves and life's journey. I guide them to find more joy, fulfillment, service and Love and to know the richness that this life has to offer.

Reflecting over my own life challenges has offered me extraordinary opportunities to experience the power of Love as the strongest healing force and life's greatest gift. My book, Follow Your Heart...Let Love Be Your Guide invites others to experience the power of Love within, creating a life filled with passion, purpose, peace and making a difference in this world.

Fearless Vision:

We must be fearless, bold and courageous as we hold the vision for humanity, knowing that led by loving kindness we may each come up to meet our highest self.

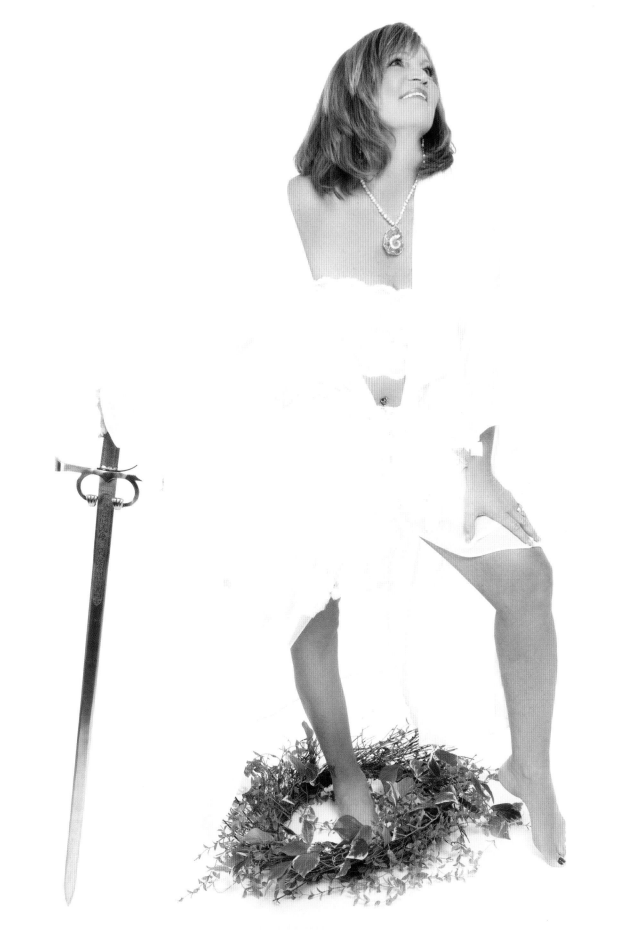

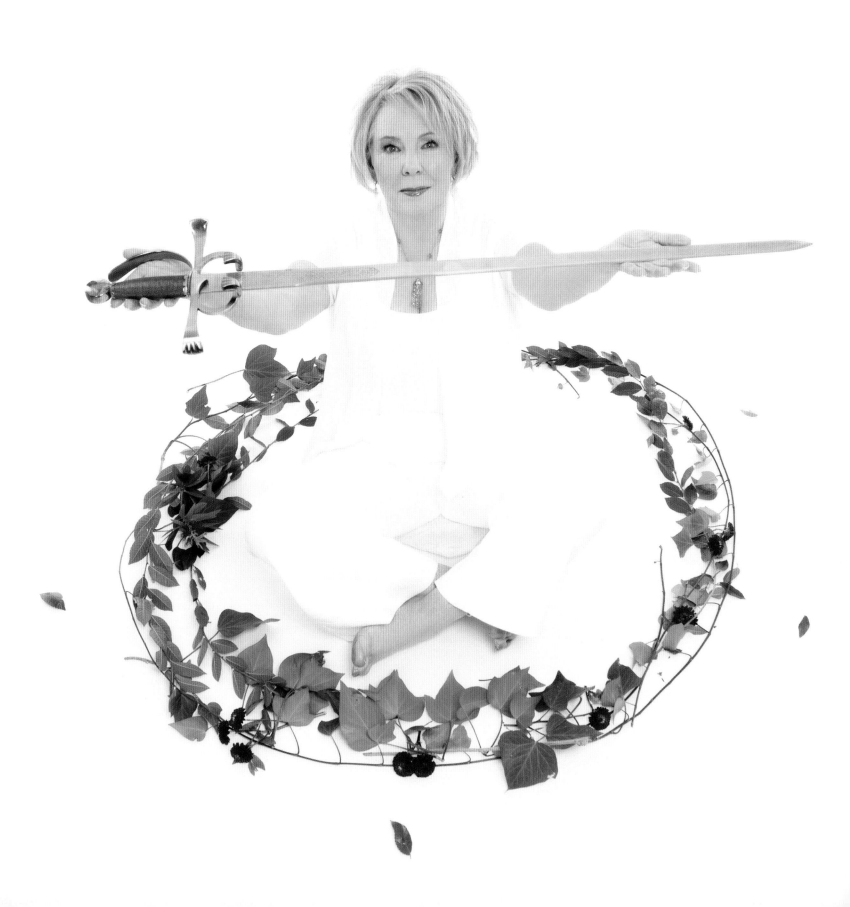

CONSTANCE F. DeWITT

When my mother died unexpectedly in 2009, I lost the final anchor of my life. I missed the conversations where we explored the environment, world population, religion and business ethics. I asked myself, "Now that there is no one to take care of, no one to care for me or care where I go or what I do or how much I spend doing it, who am I and what have I been yearning to do all my life?"

So many layers had been built up, filling the years after college with various roles as wife and employee. I really had forgotten whom I was and where I wanted to go. My life had not been a linear trajectory, but a circuitous path that kept me passionate about nature. That journey led me on a path to observing the kind of poverty that disrespects others and the environment: in Puerto Rico, in Micronesia as a VISTA Volunteer, in China and Africa, as well as here at home. What struck me time and again was the disregard for life and the planet, anathema to my frugal upbringing of composting, saving, sharing and respecting others and the gifts of nature.

My isolated life in Vermont has deepened my respect and love for the natural order. My faith and Feng Shui training, which I liken to ancient environmental science, have strengthened my belief that we are on an unsustainable course. I read books and articles on climate and changes in the universe that occur on a regular basis, substantiating what I learned in Feng Shui. It doesn't take a rocket scientist to understand what is going on around me. I can see and feel it. I see the companion economic and political changes occurring everywhere and I hear the warnings of the difficult choices ahead. But I believe that there is hope and that we all have a role to play in saving ourselves.

So here I am at retirement age, ready to liquidate everything to live my passion. Time has lost meaning. There is no fear. As a woman, I truly believe that my very DNA helps to support my vision of hope, of collaboration in business, of a healthier environment and helps me to know that these things are possible.

Fearless Vision:

I see a time when people everywhere hear the call to foster the creativity and motivation needed to survive and thrive with healthier, happier, more heart-centered global communities. A place where all people live abundantly, leaving the shadow of lack behind.

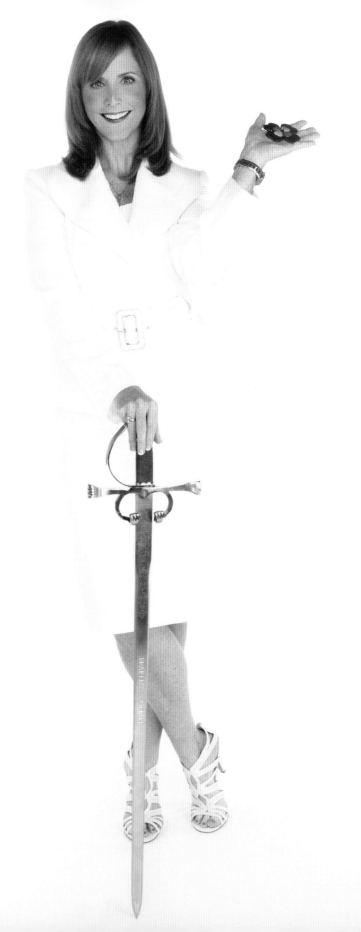

PATRICIA CONNORTON KAGERER

Women have more opportunities, more education and more choices than ever before. But all these choices can generate decisions that consume our lives, creating a sense that we are never quite measuring up.

The last few years I have thought long and hard about my life and legacy. That reflection has led me to my purpose, to be a messenger of peace. When I first heard these words in my mind, I began to laugh – loudly. How could that be? My life is the definition of chaos; a hectic career, a stressful home life with a traveling husband and two teenagers. Me? A messenger of peace? Highly unlikely!

I had always been an overachiever, seeking external acknowledgement from others that I was okay. I had received awards for my work in construction risk management. Yet my sense of each achievement never felt like enough.

On December 18, 2007 my mother Pat Connorton suddenly passed away. She was the first-generation daughter of my grandparents Thomas and Peggy Prendergast who immigrated to America from Ireland in 1928 for a chance at a better life.

Mom's death forced me to pause. I felt numb, broken. As much as I wanted everything to stop, it didn't. So, for two years I did what I did best. I overscheduled, overcommitted and overachieved, convincing myself that I was healing.

One day it all caught up to me. I felt like I was cracking into pieces. I began to write. Writing became therapy. Little did I know that my writing would lead me to the opportunity to honor my mother and grandmother and deliver a message.

My book, Wise Irish Women, serves as a reminder to women to stop, take a breath and remember where you came from. It showcases the stories of thirty-six women from around the world, each with a connection to Ireland. The message is that life was never meant to be perfect but you must go after your dreams and follow your passion. I also realized peace doesn't mean everything is quiet and tranquil. Peace means living in the chaos and remaining calm.

Mom always told me to make a difference in my little corner of the world. With just one voice, one act of kindness, we can begin. By giving the gift of really acknowledging someone, by letting them know they have been seen, we can change the world.

Fearless Vision:

My vision is for women to stop for a moment to acknowledge peace and cherish freedom. Freedom brings choices. Choices lead to purpose.

FLORA MASCOLO

After losing my forever anchor, my husband Guy Mascolo, on May 6, 2009 I realized I had two choices: to live out of aspiration or out of desperation. With this challenge at hand I embraced my most treasured pearls, my two daughters and chose the path of aspiration.

This tragic loss reminded me how fragile and precious life can be. I began to recognize that I hold the key not only to my future but to my children's as well. With that in mind I strive to be the example, showing them the strength women have to overcome life's obstacles.

Throughout this challenging part of my journey, I have kept Guy's spirit, charitable nature and vision alive. I have come to realize that the simplest things in life are what matter most. Rather than hanging on to anger and self-pity about my loss, I used my husband's strength as inspiration. I want to leave this world knowing my children have our legacy to carry on. A legacy that instills important morals and values for our daughters. A legacy that teaches them to embrace the worldwide community with compassion and care. A legacy that allows the dreams and aspirations that my husband and I always cherished to continue on, kept close to my children's hearts.

My calling from Guy is clear, to reach out to the world. To continue to live the example that he lived every day of his life. A life that inspired me to establish the charity organization, the 6th of May, to honor and remind us of Guy's impact on the world. We established this global nonprofit organization as an educational tool to inform people about all charities, big and small, existing in every corner of the world.

More than anything my dream is that every year on the 6th of May, people around the world will be inspired to log on to our site and say, "Today is the day for me to donate." Whether it's a donation of time or finances or working to better the community in some way, let it serve as a call to action for us all. Through the 6th of May I believe I can bring people and charities together creating unity in the world.

Fearless Vision:

Get involved. Be the conduit to providing freedom, recognition, strength and support to those who deserve it. Be the passion that develops philanthropy!

Jean Carpenter-Backus

Two years ago I never gave organ transplant a second thought. As a matter of fact, the thought of it kind of gave me the creeps. Some things never enter your orbit until you have to face them. I never thought organ transplant would be one of those things.

In early 2010, my sister Janet was diagnosed with liver cancer and placed on a liver transplant list. The transplant world became part of my world. The number of people who die waiting for an organ donation is staggering and unnecessary. A lack of awareness about organ donation, including fear that organ-harvesting ghouls are going to cut you up in the emergency room before you are ready to die, contribute to the scarcity of organ donors. The bottom line is that many people are uninformed and have not actually made a conscious choice to become or not become an organ donor.

The realization that my precious twin would probably die because of a scarcity of willing donors was gut wrenching for me. And in the middle of this interminable wait, I realized in horror that the little heart on your driver's license that signifies you are an organ donor did not appear on mine. I looked and looked again. I turned it over and over, staring at my license in disbelief. How could I have overlooked this? How could I, a dedicated advocate, be part of the problem rather than part of the solution? Like so many people, I was probably in a hurry and didn't realize I had not checked the organ donor box. I now carry a donor card and when my license is renewed I will choose to be an organ donor!

My mission is to increase awareness about organ donation and remove the taboo associated with it. There are many, many folks who would be organ donors if they were aware of the benefits and had the necessary information and understanding about organ donation.

On July 18, 2010, my twin received a new liver. We prayed in gratitude together as I stayed by her side until she healed and went back to work. I not only learned about the need for organ donation and transplant education, but was also reminded that there is no downside to love.

Fearless Vision:

You don't need your organs in heaven. This is in alignment with my belief that we are on earth to help each other.

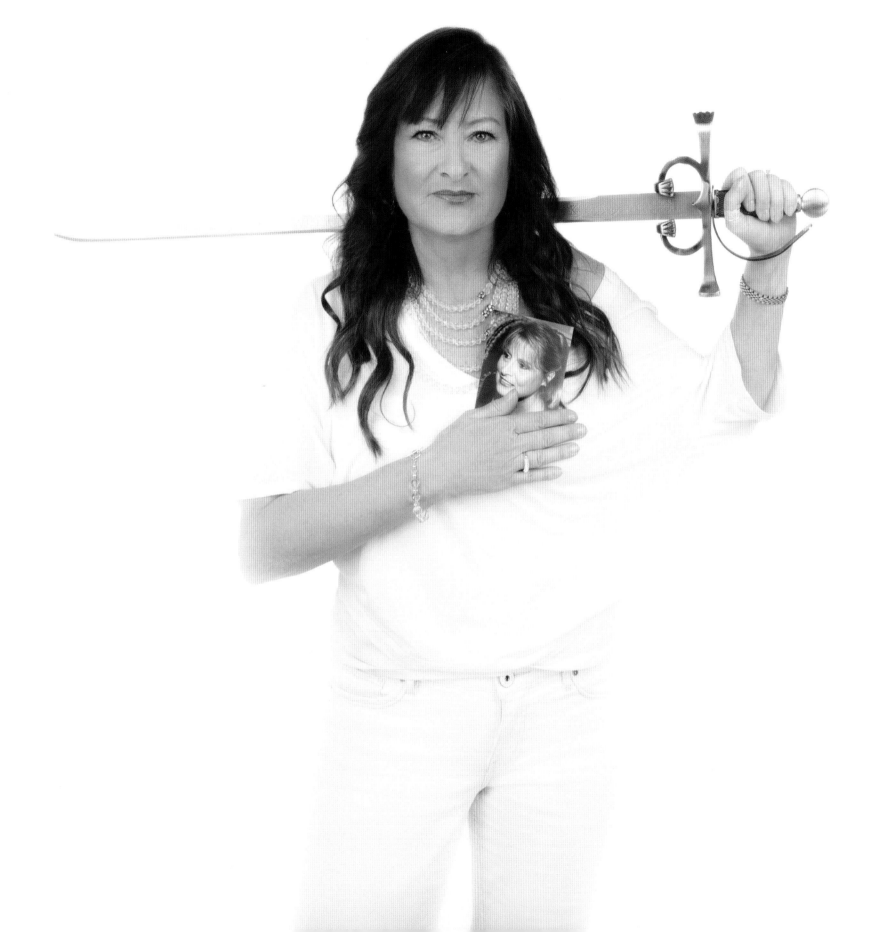

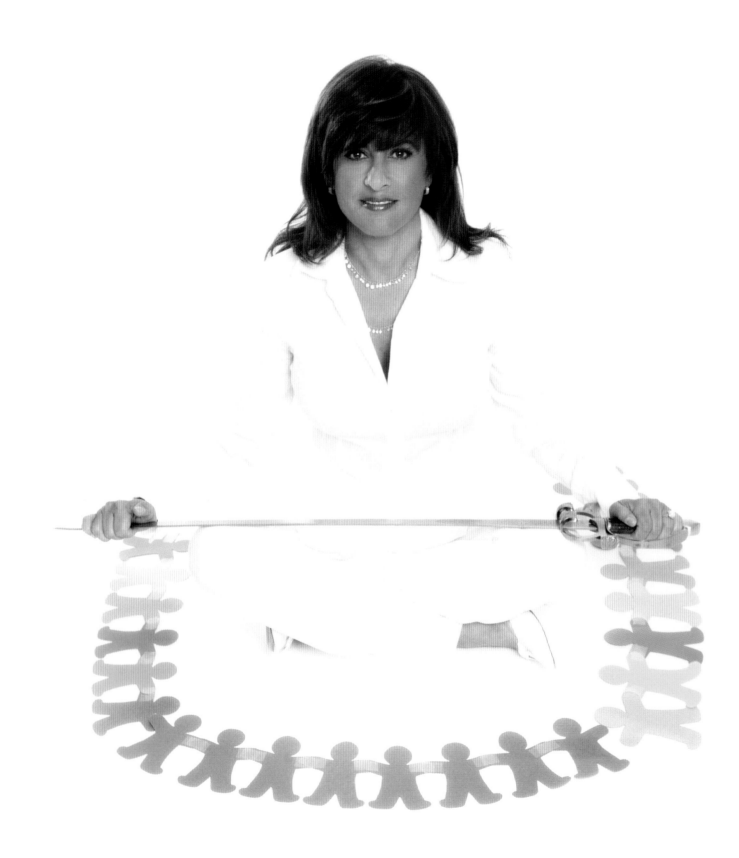

Dr. Doreen Granpeesheh

Everyone has a purpose in life. My purpose has been to bring love, hope, and strength to those affected by Autism. Along this path, I have learned a lot. I have become more aware and less fearful. I have come to realize that the Universe takes each of us down a path. What we gain from that path is entirely up to us. The children I treat and the families I have worked with are my heroes. They have taught me it is possible to see every challenge in life as a lesson. They have shown me how to be strong, how to persevere, and how to shine within the realm of our differences.

These lessons have made me a better mother, a better friend, a better person.

We all function at different levels of consciousness and we each have our own egos to manage. If we were able to overcome our fears, and see that we are all one, the world we want would appear around us.

As "One," there would be only love. When there is only love, we have found our home.

To me, life is about learning to overcome fear. I don't fear when I know the universe leads me exactly where I am meant to be.

In every moment of our existence, we can make a choice. We can choose to be one with the Universe, to give love, and to accept change, or we can struggle and fear. Let us trust the flow of the Universe; it will lead us to the New World we so desire.

Every day I remind myself to see the opportunities I am given to learn, to grow, to be strong, and to give love. Every day I remind myself to trust the path I am on. When challenges arise, I remind myself: Life is not about waiting for the storm to pass, it is about learning to dance in the rain.

Fearless Vision:

Everything I want for a new world is already here. We can all see this new world if we find the courage to pursue it. After all, the perfect world is only a canvas to our collective imagination.

TRACY JO HAMILTON

Lately, I find myself reflecting on some of life's more universal questions, "How have I arrived where I am today?" And, "What legacy am I leaving in the world?" This journey back in time to view the life events that have influenced my story feels essential to understanding my own contribution to our Global Consciousness.

My adolescent and teenage years play out like an After-School Special that warns teens and parents of the pitfalls of growing up. Embedded in the high-drama episodes are drugs, alcohol, rape, domestic violence and teenage runaway. Totally out of control delinquent behavior that left my family and me drained and bruised. By the age of 21, I had flirted with and indulged in every imaginable self-destructive element available.

What saved me from total destruction was an internal metamorphosis that has taken place at every threshold of my life. I relate it to the seemingly subtle change that activates the transformation of a caterpillar into a butterfly. This shift occurs with the appearance of what biologists term "imaginal cells." Cells that vibrate to a different frequency as they slowly and miraculously overwhelm the caterpillar's immune system, becoming nutrition for the growth of the butterfly. It doesn't take form right away but the results are undeniably miraculous and, I believe, Divine.

My adult life has taken many twists and turns. Adventures through West Africa and beyond as a Peace Corps Volunteer, 28 years of marriage and two industrious boys who are launching into manhood as smart, caring, adventurous young men making their own contribution to the world.

Though the bulk of my career has been in non-profit and volunteer work, the last 10 years have been focused on entrepreneurial endeavors and Ontological Coaching. What brings meaning and substance to our world and the potential activation of the imaginal cells within all of us is what intrigues me.

Several years ago I was trained in the Peace Circle Process through the Restorative Justice movement. The Peace Circle Process is taught and utilized for resolving conflict and building consensus. As a Spiritual Anthropologist and Universal Meaning Maker™, I have found it to be the most effective way of creating metamorphic shifts in individuals and communities. The process, like the formation of imaginal cells, is subtle yet profound. And it effects real and sustainable change where it always begins, from the Inside-Out.

Fearless Vision:

I envision an InsideOut Evolution™ taking place within Restorative Peace Circles around the world, producing a world of realized human butterflies devoted to living a deeply meaningful life on a socially conscious planet.

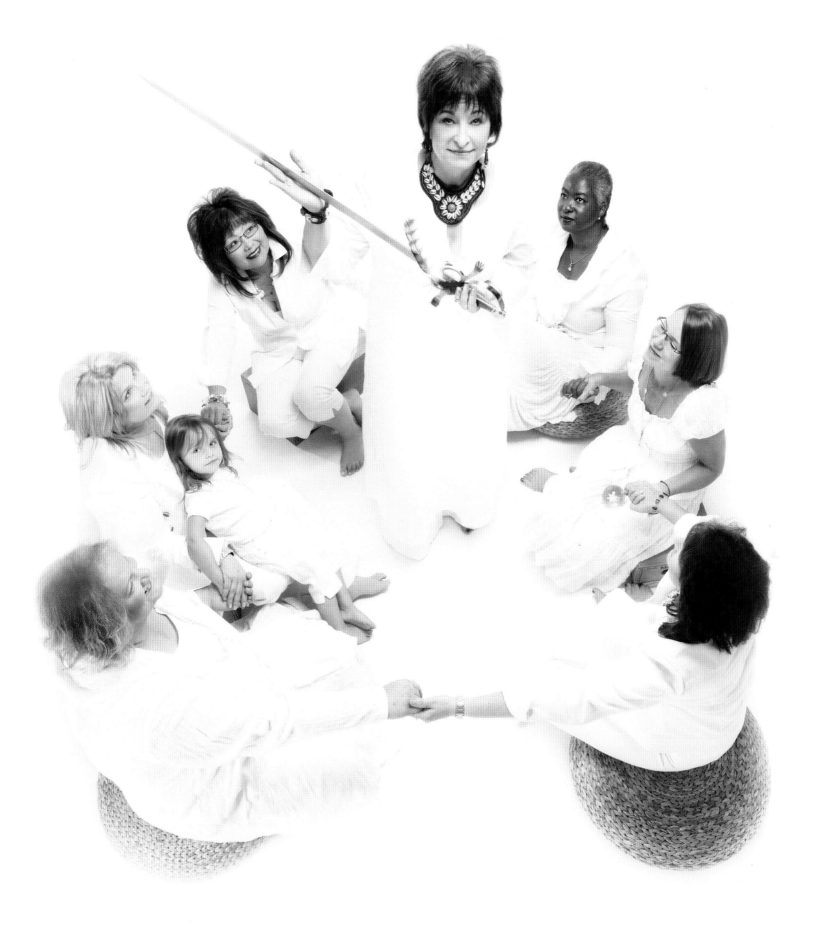

Dr. Erica Miller

I am a woman, a concentration camp surviving woman.

I have led a fearless life with a compelling mission to make a difference in the world: to inspire, empower, and guide the oppressed in their plight against degradation, abuse, and brutality.

My 'invincible life force' is a definite reaction to my early years of oppression: DON'T TELL ME that because I am Jewish I have no right to live, that because I'm a girl I cannot climb a tree or swim in the sea like the boys do. Don't tell me that as a woman I cannot have a family and a thriving career as well.

I am the founder and executive director of California Diversion Intervention Foundation, a chain of mental health centers throughout Los Angeles and Orange County. Our foundation works exclusively with the courts and probation departments in the rehabilitation of non-violent defendants who have issues of substance abuse, domestic violence, and anger management.

I am also the author of Thanks for My Journey, a Holocaust Survivor's Story of Living Fearlessly. I'm an inspirational speaker as well as a wife, mother, and grandmother. I have traveled all over the world and feel that I am a citizen of the world. I've learned that all of us 'humanoids' have the same basic needs of food, shelter, and community support.

My vision has always been – and remains during my lifespan, and beyond – a safer and kinder world.

Stay involved. Make a difference. Participate in nurturing and healing the world. In Hebrew we call this tikkun olam. It means, "repairing the world" or "making the world a better place."

Everybody matters. We all need kindness and care – as individuals, for our families, for our communities, and for the world at large. Touch a life. Lend a hand to the vulnerable and frail.

Apathy is the worst of human traits. Not getting involved, looking the other way, witnessing brutality from man to man and not speaking out is unconscionable. We are our brothers' and sisters' keepers!

Life is a gift, an amazing journey both smooth and rocky. There is no failure. Disappointments make the joy of accomplishments so much greater. Live life today. The past is gone. The future is yet to be. Live in the moment with passion and gratitude.

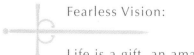

Fearless Vision:

Life is a gift, an amazing journey; live it with passion and gratitude!

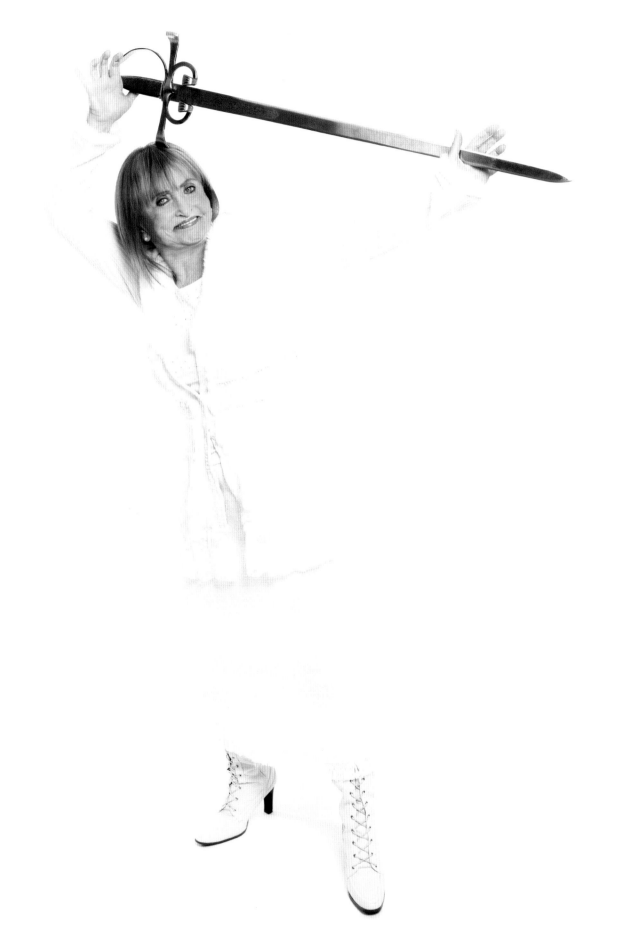

TERESA SURYA MA McKEE

How do you have less pain, stress, and fear? How do you create and sustain dynamic balance? You care more… for YOURSELF. Self-care, both practical and profound, while important for everyone, is vital for teachers, leaders and healers. Not only so they don't burn out, but also so they stay sharp and at the top of their craft.

I have a dream…a dream of fearless dreamers who are committed to manifesting their dreams. My purpose is to be a visionary teacher who influences and encourages those dreamers, healers and leaders to play a bigger game. To show up fully in the world bringing their essence into action. A world where we Fear Less and Dream More. Where dreaming is a lifestyle, not a luxury, integrated into all aspects of life - personal, professional and spiritual. For when we dream, we remember the best of who we are.

I fully believe that as dreams come true, there will be more hope in the world, resulting in a brighter future. As a Certified Dream Coach® with Dream University®, my seva, my calling, is to share with individuals and communities how to dream again…to have hope for the future…one dream at a time. In addition, I serve as a member of the Founder's Circle for the Million Dreams Campaign® in 2012. I am a student and teacher of Kali Natha Yoga.

As a Dream Coach, I am always asking myself, "How can my light shine brighter and light the way for others?" My spiritual name is Surya Ma, which literally means Sun Mother or Mother of the Light. Having spent my life in the study of being balanced, grounded and centered, I know that my essence is stronger when I honor those qualities. When you are able to maintain a dynamic balance that can move with you through the transitions of life, those transitions are more graceful, less chaotic. This leaves room for more play, more laughter…joy… love…care and dreams.

And it all comes back to caring for yourself. When you care for yourself, you create a foundation that allows you to care for others. Caring for others creates the foundation for caring for the world. And in this quest we will dream ourselves into the abundance that is our birthright.

Fearless Vision:

I dream of a world where self-care is not seen as selfish, but as an act of generosity. I dream of a world that is dynamic, balanced and integrated. A world where we truly embrace the power to manifest our dreams!

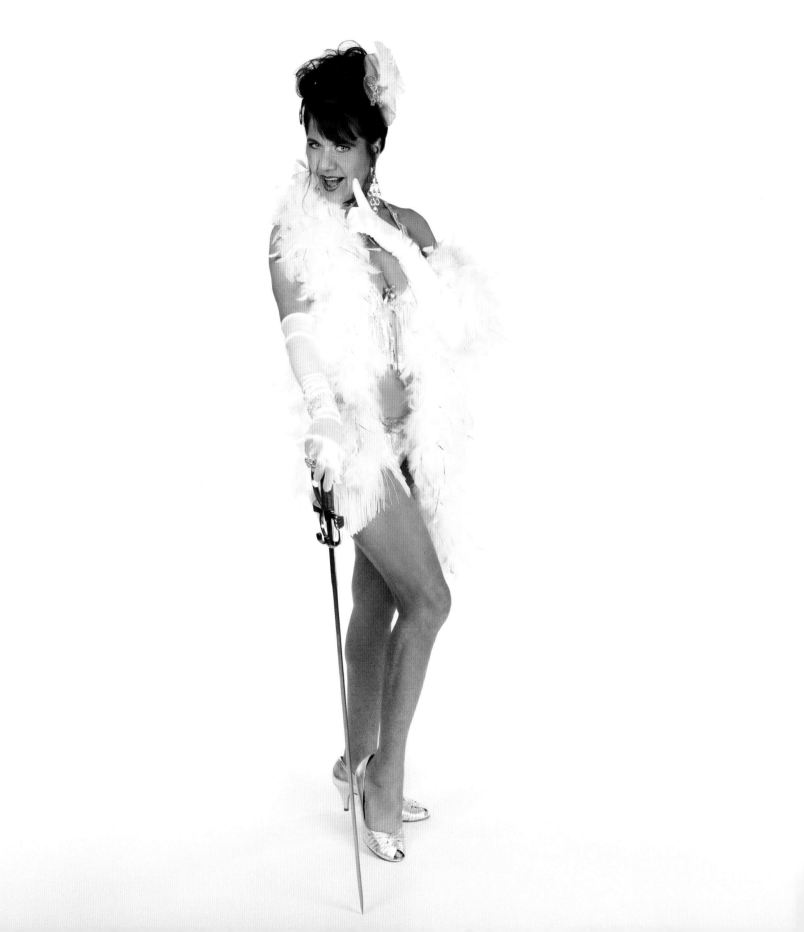

KAREN A. FITZGERALD

After a lifetime of living small and playing by the rules, can you learn to live large and create your own rules? I say YES! I'm doing it, and the results have been amazing.

Ten years ago, in Portsmouth, NH, I left an empty 25-year marriage. Okay, I may have been a bit slow to catch on but coming from an alcoholic family, this was not a surprise! So, with Al-Anon, workshops, therapy, and endless shelves of spiritual self-help books, I started the journey away from mind-numbing fear. I had to step out of my own prison, my own victimhood to realize that I had created it myself! Self-reflection can be so annoying…but useful!

Sometime after that dawning of awareness, I was invited to become a motivational keynote speaker. After some more of that intense self-reflection, I wrote, Step Into the Spotlight or You'll Spend Your Life Sitting in the Audience! It resonated big time and more conferences followed.

It relates how, for years, I had denied the very talents I was born with -singing, dancing and acting. Why? Because the messages I had received were, "Don't do that." "You'll be poverty-stricken." "It's an immoral profession." "You'll look like cheap trash!" Eventually I walked through the fear and did it anyway. I became a leading lady and during my marriage, it saved my sanity!

That was just the beginning of my metamorphosis. Seven years ago, I moved to New York City. But being limitless and free meant I would have to look at the fear that scared me most, i.e. my relationship to men and sex, or more truthfully, the total lack thereof.

That deep-seated fear took me all the way to India. The goal? To learn how to open my heart. The actuality? It opened my second chakra and men chased me all over India! The result? My comic solo show, Hot Mama Mahatma, or "I went to India to get enlightened but got turned on instead!" Again, it's resonating and I'm taking that play and message out into the world in a bigger way. Did I mention the TV script?

One outcome? I started studying sensuality and pleasure! Thus, the burlesque class I took this year and the inspiration for my picture. At 58, I'm having an adorable rebellion. I'm getting unbound and getting lots of hot dates!

Fearless Vision:

My vision of a new world is one where women love themselves, their bodies, their talents and their dreams. Where they allow themselves to do it, to be it, to live it! Maybe even in a burlesque costume!

LISA METWALY

My maiden name means, "as long as I have breath I have hope."

In 1990 my sister's breath was taken away permanently. Paula gave us 20 years of laughter and love. As an organ donor she literally gave her heart away as her last living kind act. Paula gave me hope and taught me kindness.

Everyone is a teacher. As Catherine Aird says, "If you can't be a good example, you'll have to be a horrible warning." For a good part of my life I'd been more of a horrible warning. When I lost my sister, I decided to be a better example.

On the plane the instructions are to put on your own oxygen mask before helping others. That is what I needed to do. I needed to explore how to live in the present in order to find my present. I discovered kindness as my gift.

In 2006 I joined my husband as a partner at his restaurant and we changed the name to The Q Kindness Cafe. Thanks to many believers, kindness spread. Our mayor even proclaimed the first week of every month to be "Kindness Week."

Recently a health scare led us to re-evaluate how much kindness we could bring to the world if we continued to keep our restaurant open. The kindness list was three times longer if we were to close. So we did.

Even though we closed the restaurant, kindness had grown beyond our borders - and our belief. Letters and packages of gifts to distribute came from people all around the country. I've nicknamed them "kinactors."

Kindness does travel. In my current role as a Flight Attendant I gather and share kindness among people all over the world. I've learned that you can't truly give kindness away because it always morphs and comes back to you in unexpected ways. The sky's the limit where and how kindness will take flight.

I've dedicated my life to the harvest of kind actors. I study kindness to give away. I create traveling kindness messages and gifts to treat yourself first, and then pass along. I love to connect "kinactors" so they can collaborate and expand the vision of kindness everywhere. Kindness keeps us all young at heart.

You, too, can enjoy this fountain of youth as you take flight and create a kinder community. I've created kinactor. com where you can connect, create, and collaborate to give kindness wings.

Fearless Vision:

Kindness is a universal gift we can give to ourselves and others.

JOLIN HALSTEAD

I have the gift of extraordinary parents. If prompted, I'd tell you I have the best parents on the planet. Six kids. Each one very different. Each child loved unconditionally. Each of us given plenty of space to become who we were supposed to be. Yes we had rules and consequences, but our parents' perspective on life – and raising children – was as a series of gifts and challenges, instead of problems and solutions.

As the firstborn of six, I acquired a built-in fearlessness that comes from paving the way for the rest of the "troops." I made my way into life trusting myself and knowing I could do anything. Perhaps this was because my parents gave me the opportunity to be responsible for my actions, to make decisions for myself, and to participate on an equal basis with adults. What I had to say made a difference.

I was in high school and had lived in four countries before I realized very few kids had the same experience. This is why I created Soul Purpose Parenting™.

Soul Purpose Parenting™ recognizes the privilege of "growing a child" to be the most significant role in shaping our world. It is a place where children, teens, and young adults can explore, imagine, and dream. It's an opportunity to practice life, and learn valuable, timeless life lessons. It's a way for parents and grandparents, life partners, teachers, and community members to engage and become aware caregivers who raise healthy, enlightened, self-motivated, happy kids. It is a resource, a partnership, and a community in which to begin the journey of mastery as a "Soul Keeper."

We are waking up as a nation, as a world of peoples. In universal measure we are recognizing and seeking deeper connection as we are finding ways to fearlessly champion the better part of who we really are.

The soul is the window through which the spirit grows, where love and connection is expressed. As aware parents we honor the soul of the child. Children do not need to search for who they are meant to become. They already are.

I am fearless about celebrating humanity, especially children, with the same exuberance I felt as a child gifted with courageous, loving, generous, aware parents. It is simply my Soul Purpose.

Fearless Vision:

I am fearless about bringing Soul back to parenting and education.

TAMARA ARCHER

When did mediocrity in our health become the new standard? Great health and vitality are our birthright and my line in the sand is, "Good health doesn't have to be confusing!" When we simplify our choices, we amplify our health and consequently, our lives.

I'm sure a lot of moms can relate when I say I was pretty healthy until my kids arrived, bringing home every bug they caught. Adding insult to injury, I fell into the "Mommy Syndrome," taking care of everyone but myself. When my doctor prescribed three months on bed rest and sixty pills a day, I knew I'd hit bottom.

Through this process I learned pills are not the answer; nutritious whole food is! But I was confused about what to do and whom to trust. I was almost immobilized by all the contradictory information and the realization that many of our food choices were not only stripped of nutrients but full of chemicals, additives and preservatives. For me, that was no longer acceptable. Simple changes can restore us when we eat wholesome, nutrient-rich foods. Ask yourself, "Is there color on my plate?" "What relationship does this food have to how and where it was grown?" If the answer is "little or none," move on!

We've gradually and dangerously been sold a bill of goods with the choices large food companies serve us. It is no surprise that childhood diabetes has escalated in the last 30 years. As moms, we must join together to shake off our complacency and step away from the slippery slope of convenience foods. And boy, do I understand how tough that can be!

The good news though? It is doable. When we make a commitment to ourselves and our children to eat what nourishes us - more fruits, vegetables and fresh organic food - we take another step toward conscious food choices.

It doesn't happen overnight but you can reclaim the great health that is your birthright. Women are the connective tissue, the sinew, and as healthy moms we bring power to our communities, positively impacting everyone. It doesn't matter where you are with your health today. There are choices you can make now that will profoundly impact the quality of your health tomorrow.

Fearless Vision:

I envision a world where moms are present, healthy and vibrant knowing
that when we align with purpose and intention, powerful shifts happen.

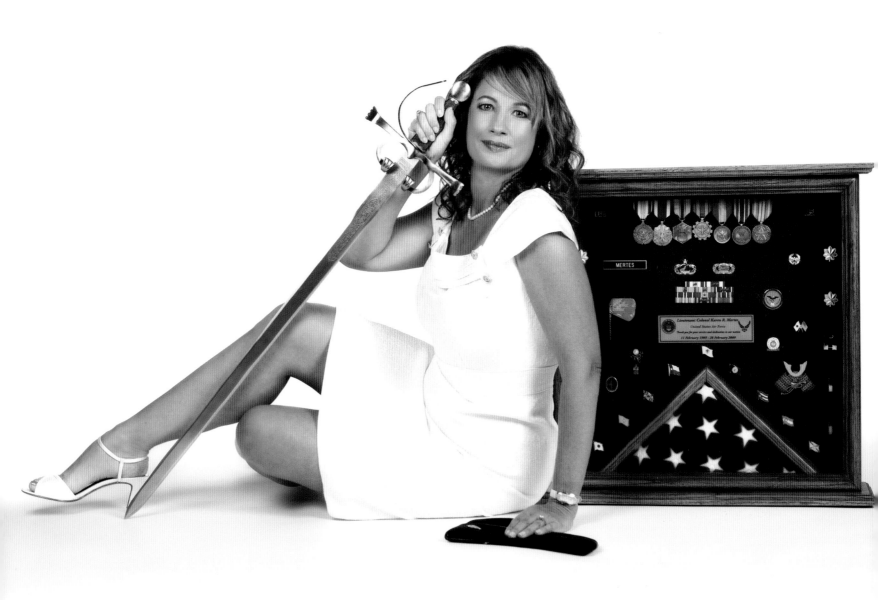

KAREN R. MERTES, Lt. Col. (Ret), USAF

February 7, 2007, was the day that forever changed my life's path. I was driving at night on the interstate when I was struck by a drunk driver with a blood alcohol level of .221 (nearly three times the legal limit), traveling over 100 mph. Both vehicles were totaled. My car's axle was snapped in half. My brakes were gone. My steering was nonexistent. My car slid for several hundred yards before coming to a stop. I had no taillights and cars were veering around me at interstate speeds. The moments following the crash seemed like an eternity. I prayed, pleaded, and promised God that if I were allowed to live, I would spend the rest of my life helping others. This was the genesis for what would later become Fulfill Your Destiny, Inc.

I was no longer the same person I was before the crash. Among other injuries, I sustained a traumatic brain injury characterized by executive function deficits. As a mathematics major, I'd risen to the rank of Lieutenant Colonel in our United States Air Force, and was a military base Squadron Commander and Chief Financial Officer. That life path had ended.

Today I'm a motivational speaker and corporate consultant. I've learned to turn what most would deem obstacles into opportunities. I'm able to touch more people's lives and I've achieved far greater success than I would have thought possible.

Fulfill Your Destiny, a 501(c)(3) nonprofit corporation, helps members of our community whose life paths have been permanently altered by unforeseen circumstances. We help these individuals become independent and successful.

Personal challenges strike each of us from time to time, most often in quite unexpected ways. How we confront our challenges is the key to my belief that character drives destiny.

At the 2011 Fearless Women Conference, I was one of seven Unsung Hero honorees. After spending over 20 years in our United States Air Force, I'm quite attached to acronyms. When I see the word "Hero" I like to think of "Hands Eagerly Reach Out."

When we dare to care, our Hands Eagerly Reach Out to help others in need. Imagine how strong every community could become if hands eagerly reached out to help others who have lost their life's path. This is my goal and – with God's help – my Destiny.

Fearless Vision:

Your worst day can become your 'best bad day.'
Embrace this. Fulfill Your Destiny.

TABITHA KYAMBADDE

It is 1999. I arrive in America, the ultimate land of opportunity. I had read and heard much about the American dream and had come to believe that in America anything was possible. I thought life would be quite easy once I arrived in the land of plenty so I jumped upon the opportunity with no second thoughts, leaving behind my kids at a tender age. After all, I left Uganda to continue my studies and give my children a better life.

I soon discovered that life was not as easy as I had anticipated. I spent countless hours thinking of how my children were handling life without their mum. I felt guilty for having left them behind worried that they would think I had abandoned them. I found the nights too long as I begun to cry myself to sleep every night.

However, during the daytime I would try my best to concentrate on what I thought I came to accomplish. I worked as hard as I could, trying to save a penny here and there to send back home to the kids, to maintain myself and to keep in school. Unfortunately, in 2009 I lost my job but instead of wallowing in pain, I decided to look at it as an opportunity to look into a variety of other possibilities, a choice I now look back upon as "a fearless decision."

A year later, I met Betty Liedtke, who introduced me to the "fearless tribe" which I wholly embraced. Now, looking at the disadvantaged women of my country reminds me of the time when I had no opportunities to fully exercise my potential. By the inspiration of the fearless attitude, I refuse to look at their disadvantage as failure but as an opportunity to inspire them. I can see clearly the purpose for my journey into the US.

I am now able to imagine a world full of happy children and women. A world where each child is looked at and treated equally, where every woman is given profound love regardless of her status in society. A place where we hold hands together to share, laugh and embrace each other without discrimination. I see myself being able to hold onto these ladies, smile at them and say, "It is well." In the end, I trust that the single act of lending a shoulder to lean on will gradually transform communities and give them hope.

Fearless Vision:

I envision a new world where every woman, man and child will reach out to each other in love.

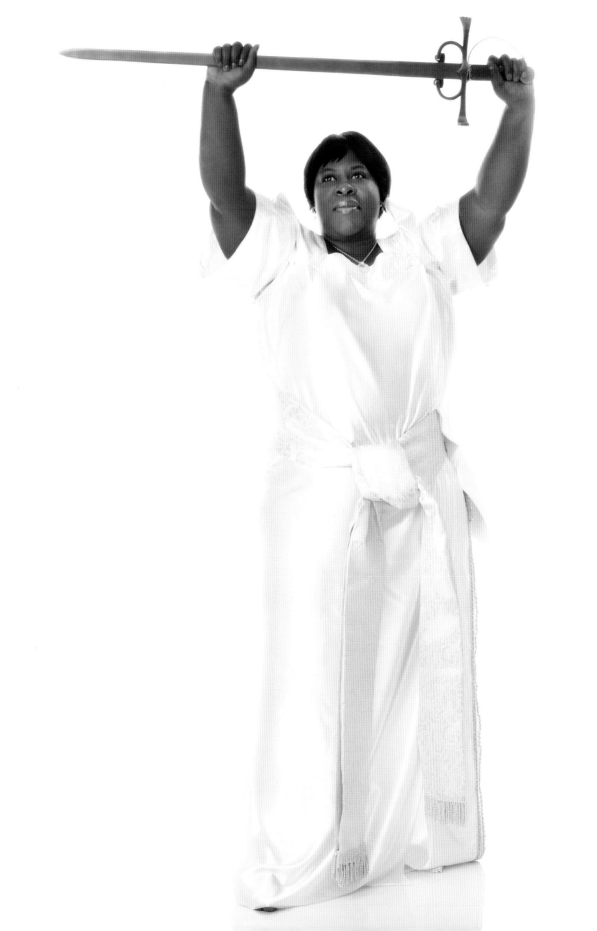

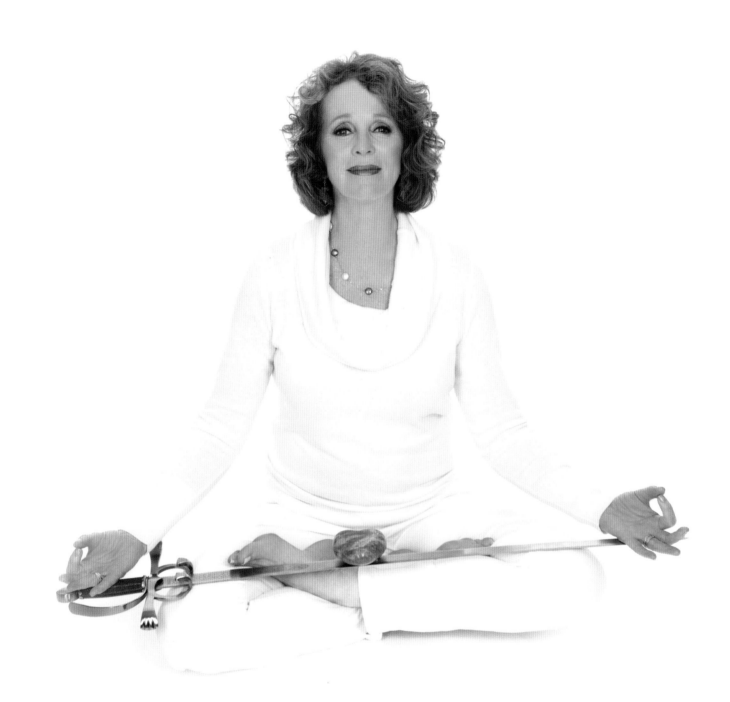

KATHLEEN HANAGAN

Since I was a young girl, I have known in my heart that the visible world was not the only reality. My first spiritual teacher, my maternal grandmother, validated this knowing. I have never ceased nurturing that seed.

In college in the '70's, I found others who shared a similar knowing and the vision began to take shape. As marriage and motherhood consumed me, amnesia set in. I bought into a fairy tale that led to depression and eventual divorce. No guru, therapist or card-reader could give me the antidote to the restless spirit inside, and I began, while in a well of despair, to hear the voice of my own naked truth.

In 2004, I closed my successful psychotherapy practice, sold my house and headed for the high Andes. There I reconnected to what is possible and claimed my role as an inspirational visionary. I was no longer willing to deny who I was.

What is emerging for me now from my last huge metamorphosis is the burning desire to do a one-woman show. To get the message out to as many women as possible that we must dare the dark, surrender whom we thought we were and step into our magnificence. What became clear in the very, very empty days following my latest awakening is that my present work has been but a stepping-stone; that there is a far more fun, direct and effective way to accomplish my mission of weaving a global web of women helping women.

I believe it is the time for women to step into spiritual maturity, each shining her unique light into the world. As an open channel to the flow of love and money, my intention is to create a foundation to advance this purpose, helping to facilitate each woman's growth into her full magnificence.

It takes courage to give up dissatisfaction, to relinquish doubt to create a New World. Coming from compassion, calling forth the courage in others is my greatest joy. Allowing that compassion to guide my life, I have stepped into the vision I've carried for so long. A one-woman show!!! I have secretly always wanted to do one. It is a long shot, but then again, what isn't?

Fearless Vision:

Dreamers are people who hold to a vision when everything seemingly points to its opposite. I see a world where powerful visionaries claim leadership roles everywhere, knowing there is enough of everything for everyone.

DR. KATHLEEN A. HARTFORD

"May I please speak to Mrs. Rixon?" "This is Mrs. Rixon." "Was your husband flying at Butler County Airport today?" "Yes." "There's been a crash." I felt the blood drain from my body. "Mrs. Rixon, he's in critical condition. Come quickly."

At the hospital, I was informed my husband's brain was swelling. He was in a comatose state. "Your husband isn't coming home, and if he lives, you will need to place him in a home for head injured people for the remainder of his life." I looked directly into the neurosurgeon's eyes and pointedly replied, "You save his life. I will take it from there."

That was April 17th 1994. The day my fearless vision for the future took shape. I quickly realized that healthcare was a limited, fear-based system. If Gordon did survive, I knew that medicine alone was not going to return him to his highest level of function. So often we overlook our body's innate healing ability. Instead, we aggressively use medicine, which often creates more challenges than the disease or trauma we are fighting against.

We know the body can heal itself, but we need to continuously ask, "What does the body need right now to accomplish that healing?" The neurosurgeon wasn't wrong. He was speaking from decades of experience with hundreds of brain-injured patients. His job was to keep Gordon alive. My job was to see that he obtained every opportunity for healing. Every day for four years, I asked the question, "What does Gordon's body, mind and spirit need today to heal?"

Over the years, I have asked this question relative to every human ailment that walks through my clinic doors. Mindful of this mission, I honor my fearless vision to integrate and balance the five aspects of health:

1. Neurological – the seamless communication from the brain to the body.
2. Bio-energetic – the flow of energy between the body's organs.
3. Bio-chemical – the necessary nutrients to nourish and protect us from harmful environmental and pharmaceutical chemicals.
4. Emotional - understanding that every event in life, good or bad, leaves a blueprint of emotional reactions that requires balance.
5. Spiritual – acknowledging that we are so much more than the sum of our parts.

Whether you have been in a plane crash, suffered through emotional trauma or have any of the preventable diseases of aging, you deserve the opportunity to express your fullest health potential.

Fearless Vision:

By enhancing the five aspects of our health, we can become the fearless expression of the exciting life that lives inside each of us.

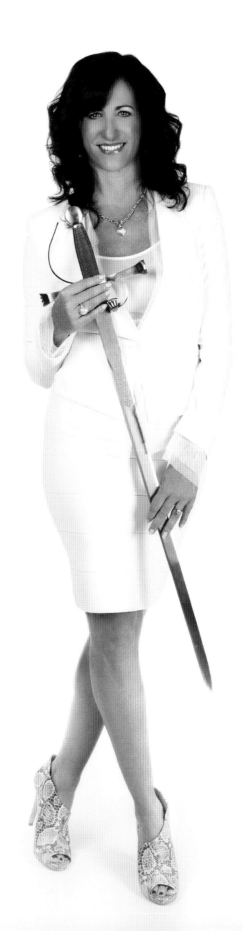

Dr. Shiva Lalezar

At the age of six, on the streets of Tehran, I was terrified hearing people shout, "The Shah Must Go!" Noise of gunshots and the madness was overwhelming. I found myself on a plane to Israel overnight. The terror didn't end, as now I would have to deal with the ridicule of not speaking Hebrew. A year later, at the risk of assassination by the Islamic regime, we returned to Iran to free my dad from jail and realized we were not allowed to flee the country since we are Jewish.

We lived through ten years of bombings. Seeking safety at my father's farm proved no refuge, since I was terrified of rats. Although the theme around my childhood was fear, I was considered a strong willed, intuitive, and powerful girl. I often led games and activities to empower other kids, despite my own inner fears.

At sixteen, my determination to become a physician inspired my dad to find a way to send me to the United States. In spite of speaking only a few words of English, within one year I was studying Shakespeare, soon graduated from UCLA with honors and pursued my studies in medicine. In medical school, I spoke of my knowledge of natural medicine and questioned prescriptions of synthetic hormones, only to be shouted down by my supervising doctors.

Upon completion of my residency, during the worst economic conditions, I started my holistic practice. Many colleagues said, "You are crazy!" My fearless pursuit of my dreams manifested the Health and Vitality Center where thousands of patients have been healed of their lifetime illnesses. Rather than a "pill-pushing approach," I determine the root cause of illness through the practice of functional medicine.

I am also proud of my marriage where day-to-day challenges are addressed with courage and communication. The natural birth of my beautiful twin girls has been more empowering than everything else I have accomplished. I gave birth without medication, delivering them into my fearless world with an extraordinary vision for life itself. I now take my girls to work with me, breastfeeding in between patients.

My fearless journey is just beginning as I nurture my vision of writing books, lecturing nationally, and being a political spokesperson for the enhancement of medical education and incorporation of functional medicine nationwide.

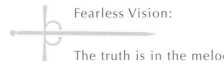

Fearless Vision:

The truth is in the melody of your heart. Manifesting the truth is overcoming the fear in your head.

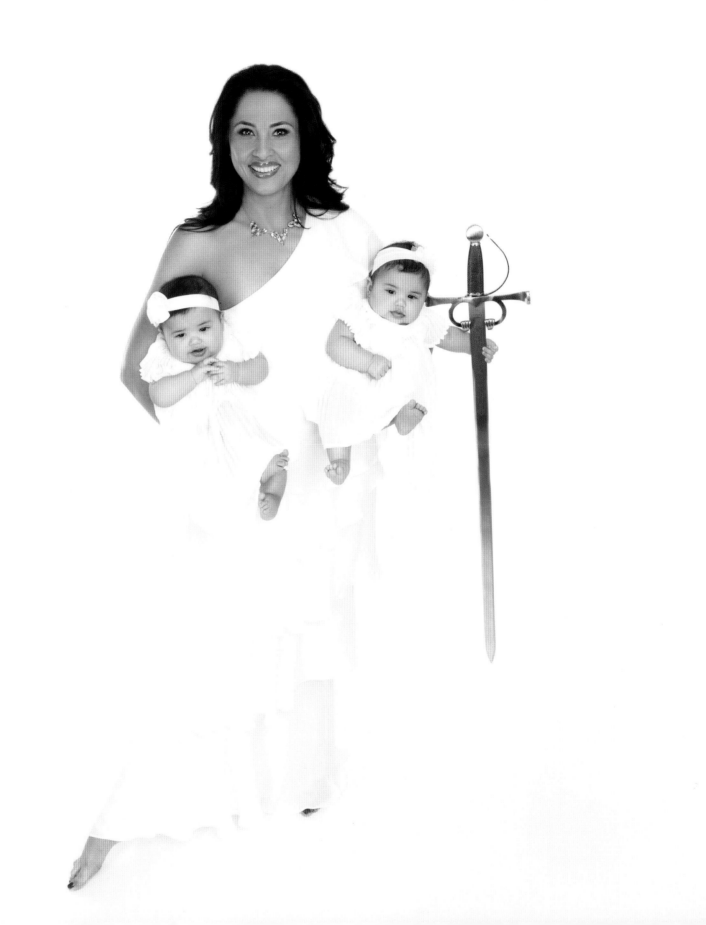

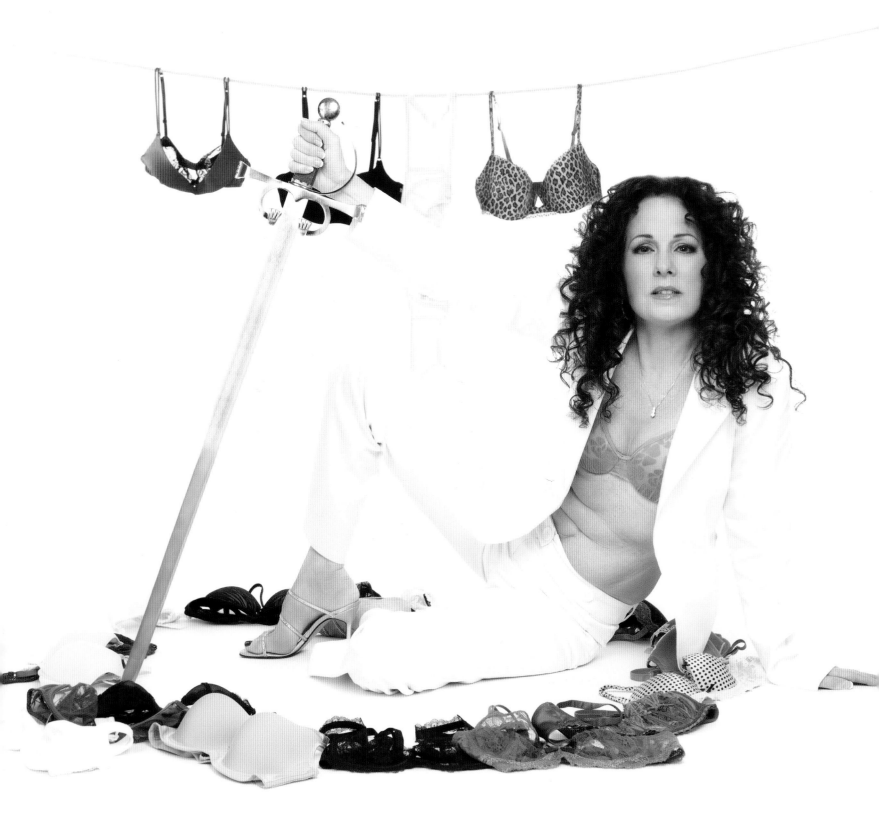

SHELLY MANOUGIAN

Soon after losing both my parents, I had the realization that life is too short not to follow my dreams. Having spent many years establishing myself in intimate apparel and becoming the "top bra fit specialist in the Seacoast area," I opened my own shop in Rye, New Hampshire. I found owning my own business and helping women feel good about themselves incredibly fulfilling!

Two years after opening my shop, I was diagnosed with stage-three colon cancer and told I had a 20% chance of survival. A total hysterectomy and surgery to remove a cancerous tumor on my colon followed. After a six- week recovery from surgery, I underwent chemotherapy, four full days a week on a biweekly basis, for eight months. Despite being sick and exhausted, I managed to be at work. If I wasn't in the hospital, I was at work.

During this period, I met many new friends who were stricken with the same dreaded disease. Through the gift of these friendships, I learned even more about life's frailties and the strong bonds that life has to offer. I sat together with my new friends in the same room, fighting the same battle against the same deadly foe. Our bond was an extremely personal one as we all faced our own mortality together. We shared our lives, our hopes, our dreams and our fears.

Before my treatment ended, several of my new friends were forced to face the ultimate fear as they lost their battle to cancer. The intensity of those short but meaningful friendships meant the world to me. And the constant reminder of the mortality that I was facing myself made those losses so emotionally painful. My illness brought a sense of stark reality along with an inner strength that only a cancer survivor can experience.

During that time, my shop was named as "one of the 100 top bra fitters in the nation" by Oprah Winfrey's website. Many of my customers would come in exclaiming, "Oprah sent me!" or "Your shop was mentioned on Oprah's show!" It was a huge and much needed boost for my business.

Being a "survivor" has made me realize that this disease can be fought and life can go on. As a board-certified mastectomy fitter working with breast cancer survivors, my passion is to help other women fight their battle, giving them confidence to feel whole again while they regain their lives.

Fearless Vision:

When a woman feels comfortable within, she exudes confidence. And a confident woman can do anything!

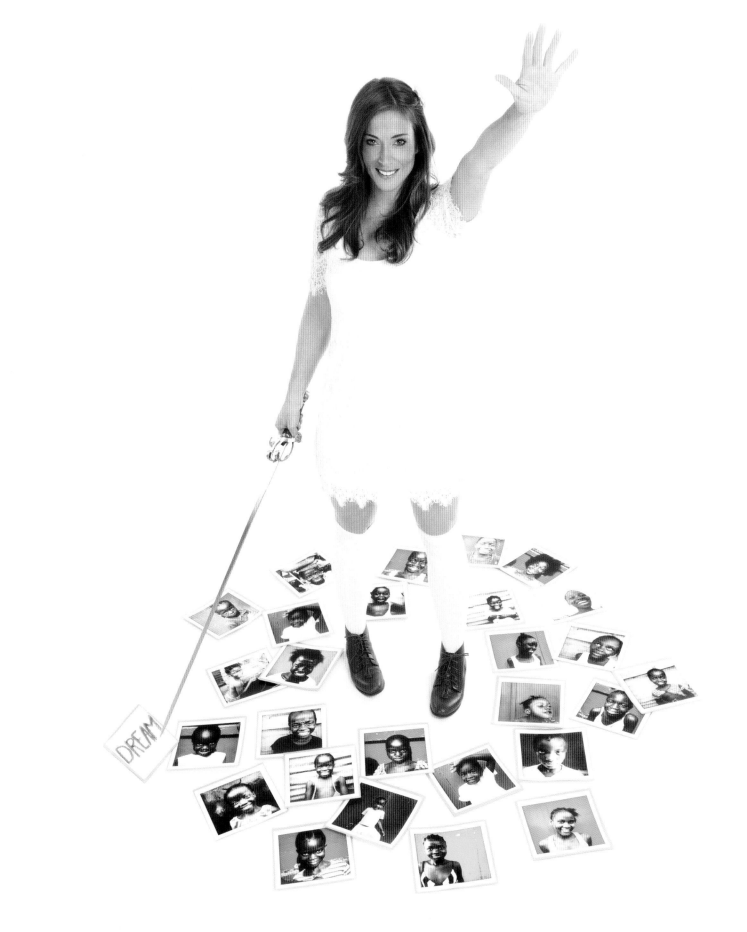

It's a rainy day in Liberia, West Africa. I'm writing this in an Internet café I ducked into to escape from the pounding rain. The rainy season lasts half the year here.

Today I'm on the hunt for a home for six child prostitutes. When I ask these girls what it is they want they reply, "We want a home, someone to love us and help us go to school. We want clothes, food, and teddy bears."

I didn't always care about making a difference. My own childhood was filled with chaos, drugs, and abuse. At eight years old, I woke up next to my dead uncle who had died of a heroin overdose. My older sister – my hero – was in and out of rehab, mental health and youth correctional facilities for drugs and suicide attempts. My mother escaped her stress and pain by getting drunk. The police knew our family by our first names.

Everything changed in our family when we started going to church.

I thought I had a hard life, but when I was a teenager I went to Central America with my youth group. I met kids who slept under cars at night to keep warm, who had no shoes, and struggled to find food to eat. I wanted to do something.

I was the first person in my family to go to college. After I graduated, I got my first job working in Liberia, West Africa, where I lived at an orphanage with 86 kids whose parents had been murdered in the civil war. I met many kids who asked me to put them in school, which was not yet free in Liberia. So I did.

At age 27 I formed a non-profit. More Than Me helps some of the most disadvantaged girls in the world get off the streets and into school. We are currently helping 100 girls by providing everything they need to get to school and stay there until they graduate with a high school diploma.

But we need to do more.

We want to extend this opportunity to many more young girls. We want to provide counseling, mentorship, and vocational training. We want them all to learn how to use media such as phones and the Internet so they can connect with the world beyond what they've known.

More Than Me is about living for something bigger than just ourselves. All the time. No matter what our age or where we live.

Fearless Vision:

We are not enemies.
We are not different political parties.
We are not our governments' armies.
We are humanity.

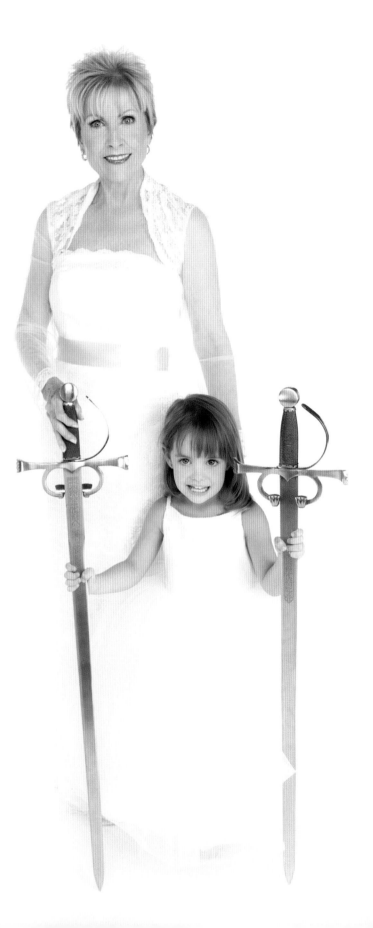

KATIE LAINE AND ABIGAIL OLIVIA LAINE

When I was 9 years old, two of my friends who were angry at each other came to me. I suggested the three of us talk it out, and we were able to resolve their differences. I had just conducted my first mediation! Little did I know this ability was the essence of what would become my purpose: to help people know who they are and how to give their unique contribution in this life.

Years later I started my own business, Discover Consulting. As a communication specialist and executive coach I pursue my life-long passion, assisting people to find meaning and value in their personal and professional lives through awareness and authentic communication.

One of my passions is helping men and women value and honor each other at work and at home. Finding common ground between men and women adds magic and meaning to our lives. Through my work, I've had the opportunity to listen to many men who care about honesty and integrity, men who value the success and well-being of their companies and their employees. As a result I've experienced a profound healing of my own attitude towards men.

I was married for 20 years, then single for the next 20. This year I was blessed to marry an amazing man whom I met two years ago. Before I met this man my wise granddaughter Abby helped me realize that my true objective isn't to find someone to fulfill me by loving me. It's to find the love within me and give it generously. It's never too late for love – or for anything you decide to experience or create.

This is why my sweet Abby joins me in this portrait. When I asked her if she would rather share my sword or have her own, she was clear that every generation needs its own sword! Abby continues to inspire me by being a shining example of the fierceness – and gentleness – of true power.

I've come to believe that 99% of people genuinely want to get along. With a few skills, people can quickly learn how to share their perceptions in a way that creates mutual safety and understanding. Once that occurs, human ingenuity and creativity are freed up to resolve any challenge.

Imagine a world where people know and honor their own value and that of those around them! Everything becomes possible. We are truly all connected in this great circle of life!

Fearless Vision:

Transforming ourselves and our world, one genuine conversation at a time.

Sarah-Jane (SunJay) Owen
& Perfect 5th (The Martin Sisters)

In many native traditions, when you become an elder it is time to pass your knowledge to the next generation. When I met the girls of "Perfect 5th," they were singing cover tunes with a lot of enthusiasm and potential, though I could see they needed guidance and direction to polish their craft. Having been in an all-girl band myself back in the 80's, I related to them and felt I had wisdom to share – so I volunteered to mentor this group of young women starting out on their maiden voyage.

The sisters, age sixteen to twenty-two, hold a powerful intention to be positive role models for people of all colors and ages. Their upbringing in Mexico was musical and multi-cultural:

"As kids, we just wanted friends to hang out with, so we looked beyond differences in clothing, customs and nationality. We celebrate diversity by using different cultural influences, rhythms, and even languages, in our music."

I wrote them a song about visions of a new world, which offered them the chance to be on this book's CD. The recording process pushed them to a new level of professionalism. My skills as teacher and mentor were also tested, as I sought to balance encouragement while striving for excellence. They scaled a sharp learning curve to rise to the occasion and I am proud of the focus and dedication they summoned under a tight time schedule.

As a design instructor, I have been able to give the girls specific, practical guidance in their choice of clothing, encouraging them to recognize that young people may emulate them, which brings a responsibility and an opportunity for them to make a global difference by choosing sustainable attire and developing a style that honors rather than degrades the feminine.

Looking back at my own life, I am so grateful to mentors who encouraged, led, shared, taught and handed down their precious pearls of wisdom to help shape who I am today – art professor, musician, shamanic healer, yoga instructor, and women's retreat facilitator.

It is now my turn to join a blessed line of elders, and to serve these young women on their journey, knowing that in turn, they will empower others and make a difference to our precious planet.

Fearless Vision:

The gift of mentorship empowers the next generation with seasoned wisdom, enriching the future of our global family.

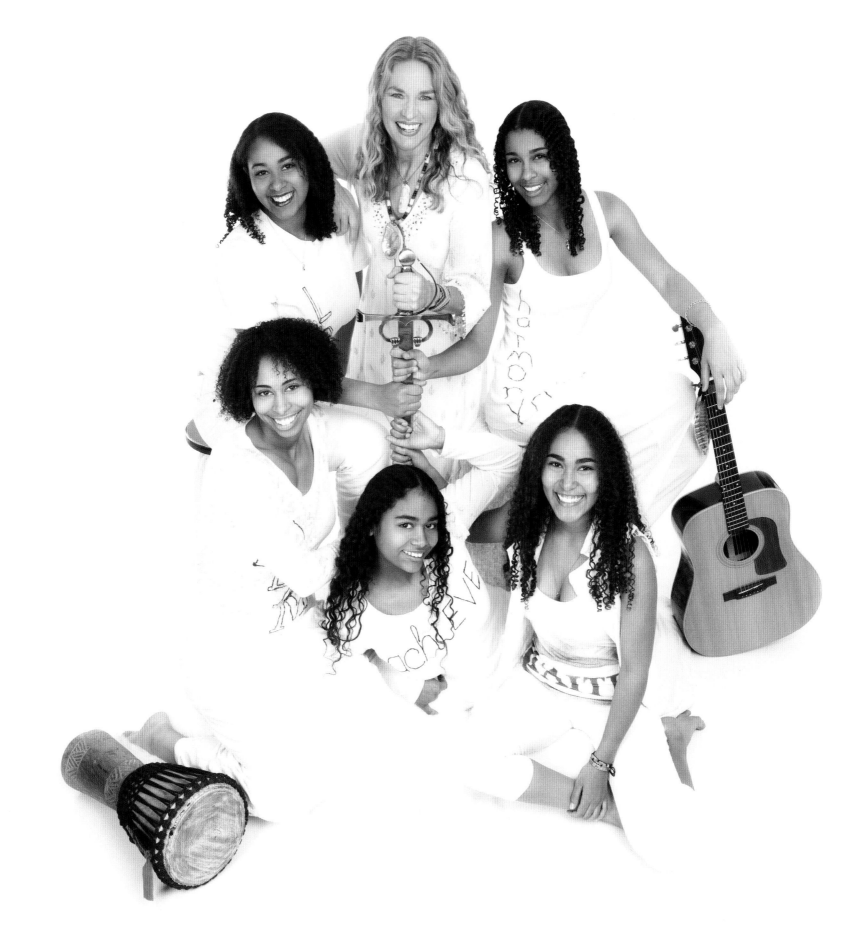

ROSEMARY MCDOWELL

I believe that a clear vision of what we want makes all the difference in our world. Helping you ask for what you want - not just what you are willing to settle for - and assisting you in making a commitment to that desire, helps define my role as a fearless visionary!

Strength, flexibility and confidence; three qualities I believe are necessary for moving forward. Strength supplies the power to share knowledge, nourishing body and soul. Flexibility represents the one constant; that things are always changing. Confidence gives you the strength to move forward no matter what! Every decision I make helps define who I am and in turn how I assist others. Utilizing these three traits, I guide others on their own personal path to making a difference.

But the path is not always easy! If you're unhappy with yourself, you can't move ahead. Consider the roadblocks in your life not as stumbling blocks from which you cannot recover but rather as learning tools that invite growth.

We live in an age where reaching out worldwide has never been easier. Through my laptop I connect with others, helping them balance material developments with humanitarian values. Removing obstacles from our path, erroneous information, faulty concepts and unqualified support, is the first step in achieving that clarity.

You may find yourself stuck at times, living in the 'have-to' quotient – "I can't do this because I 'have to' do that." To truly live your vision you must believe and indulge in the 'want-to' quotient. Through an attitude of desire you can achieve anything, including ensuring the future of our planet.

Now is the time to commit to ending poverty, disease and anything that brings negativity into our lives. When we commit to living in an optimistic environment where we are all equal, we perform tasks we enjoy. Tasks that improve our universe, be it scientific discovery, technical innovations or artistic creations. The perceived right to human health and wellness has a direct effect on the way we live. I ensure that you have access to key resources by dispensing accurate information, creating effective solutions, and coaching you to take ownership of your future. Never give up on your dreams even if the journey isn't as straight as the crow flies. Very few of us actually do fly in a straight line!

Fearless Vision:

My vision of a new world is one where people have the strength, flexibility and confidence to step into what they want, knowing the universe will support them in their dreams.

KIMBRA NESS

Four years ago, my older sister Marcella died of brain cancer. Fortunately, we were able to treasure time together – but too little too late. We had gone our separate ways, and communication was weak. I often feel her presence around me and believe it is no coincidence that shortly after her death I created new lifetime friendships, and old friendships matured with very heartfelt and purposeful meaning.

In the years that followed I would grieve for 10 more family members, including my father who died on Christmas Day, 2009. While struggling to keep some normalcy for my family, I soon discovered that even while I was burying loved ones, my marriage of 30 years had failed. I was faced with lies and infidelity, and was struggling with what to make of the past and what little truth existed.

I had already faced my own battle with cancer, suffered the loss of a child through miscarriage, and now 10 deaths and a divorce. I was fading in faith, grace, and hope. On my knees, I begged the Lord to rescue me, to stop.

But to stop… what? Life? All of this was part of life.

It was then my father's encouraging voice echoed, telling me to "be the woman your mother and I raised you to be." But who was this woman? Then, allowing myself to look within, I felt liberated.

I've learned to "own" my focus and to live a life by example, being the change I wish to see in the world. Challenging? Of course, but so enlightening.

I am no different than you, going through the motions and motivations life offers each and every one of us. I wish I had all the "right" words that would magically reach everyone with lasting wisdom – simple yet revolutionary words that would describe the feelings in every soul and deliver truth. Hard as I try, this is not possible. My only insight in life is experience, and a personal vision into my new world of peace and contentment.

Those years of grief and sorrow were also filled with graduations, engagements, weddings, travel, and the miracle of birth. I'm not only speaking of my own re-birth, but the birth of my first grandchild. Suddenly leaving a legacy is important. Now my Vision of a New World is through the eyes of a child.

Fearless Vision:

I fearlessly mold the future with gratitude for past blessings and enrichment.

SHELLEY HARPER AND LESLIE BELCHER HUSTON

My sister Shelley and I share the bond of kinship, that unbreakable cord that links us together and has allowed us, through fierce determination, to conquer the difficult lessons of our past. We have put this theory to the test as we've faced life-altering challenges.

Fear and failure were never an option for us. We both understood that change only happens when the pain of holding on is greater than the fear of letting go. I bravely overcame years of substance abuse and have been free and sober for 20 years. Shelley courageously survived her husband's suicide. Together we refused to allow our lives to be defined by negativity or the need to live in the shadow of our struggles. We decided in those dark moments that we would use our adversities to help others find their voice.

Over 10 years ago Shelley and I lovingly put our creative spirits together and created Accessoreez, our unique art glass jewelry line. We use our company and our elegant jewelry designs as a vehicle to reach out, empowering women to feel beautiful and worthy. Many of our designs include spiritual messages through placement of specific stones, gems, colors and materials. We create pieces for needed energy such as strength, courage, determination and fearlessness.

In addition to Accessoreez, we also created Meridian Homes & Land, a company that devotes a portion of its profits toward creating an addiction treatment facility in New Mexico. The space is called Finding Your Miracle and promises to fill a void where the need is great and no support currently exists.

We want women to know that change comes one step at a time. We sometimes forget that even the greatest change started with a single step. Without that critical first step no other steps can be taken.

Shelley and I have taken those critical steps, reaching out to women, lighting a path to freedom and fearlessness, lifting them up until they are able to stand on their own, knowing the power that lies within.

Fearless Vision:

Our vision for a new world is one where each and every woman creates her own destiny, achieves her highest goal and then lovingly passes her gifts off to another.

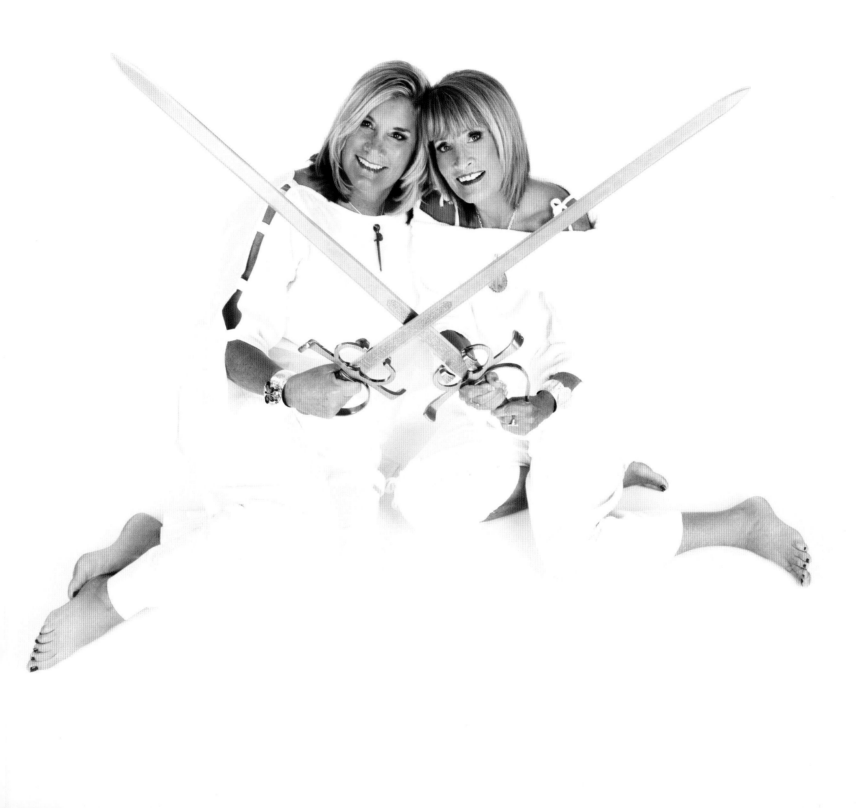

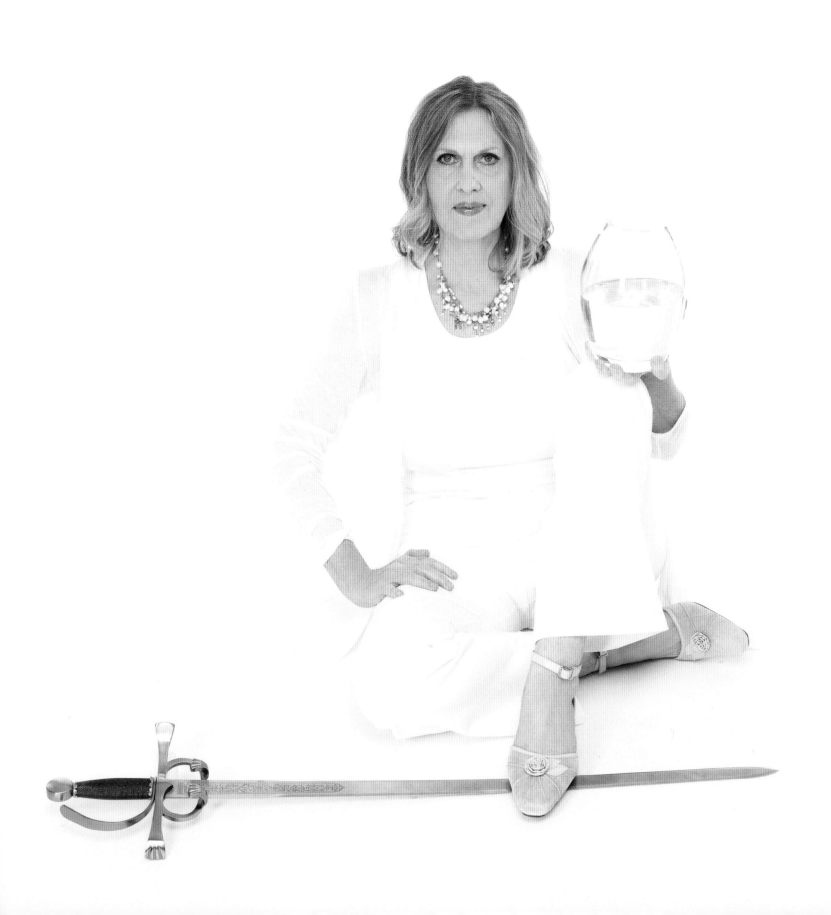

There is a new energy unfolding. Many are feeling called to something powerful and new, yet we don't quite know what to do, or even how to begin.

Old forms, behaviors, relationships, and even governments are crumbling or no longer hold energy for us.

Transformation can be fearful. Yet instead of getting stuck in panic and collapsing, a Fearless Visionholder feels drawn to keep moving ahead... into the new.

A Fearless Visionholder is one who remembers how to "turn the dial" from the frequency of fear to the frequency of love. We begin this process by letting go of old stories and by paying attention to our thoughts, words, and actions.

A Fearless Visionholder asks herself, "What is the most loving and fearless thing I could think, say, or do in this situation?"

A Fearless Visionholder does not solve problems so much as focus on what he or she would like to create. She notices the problem but doesn't feed it with her energy. Instead she turns her attention toward what she would like to manifest in the world.

A Fearless Visionholder is aware of, and supported by, the fact that the largest part of Being is non-physical and that the universal energy field is the place where transformation begins.

A Fearless Visionholder knows that the most powerful point of transformation is that part of Being that is always connected to Source.

A Fearless Visionholder knows that "Source" is not only a spiritual term; science tells us that everything is energy. Therefore each human being is a spectrum of energy. At one end of the spectrum is the physical "you." At the other end of the spectrum You exist as pure Spirit, as Source.

Being a Fearless Visionholder is about shifting your awareness toward the non-physical end of the spectrum while staying firmly grounded in physical reality, but in a new multi-sensory way.

The work of a Fearless Visionholder is to clear away the illusions that keep us from knowing who we truly are.

It's about shifting – and lifting – the frequency of our personal energy so that we may physically embody and express much more of who we truly are: powerful, creative Beings with dignity, direction, and purpose.

As Albert Einstein said, "You cannot solve a problem from the same consciousness that created it. You must learn to see the world anew."

Fearless Vision:

As I become clear in my Being and fearlessly hold my vision, I create a new world.

Rose Pagonis and Dimitra Vlahos

My mom has Alzheimer's Disease. Alzheimer's Disease is what she has. It is not who she is. For the last 13 years of her life, Alzheimer's has defined her existence. Prior to that my mom had a life story. It is a magnificent story and one that needs to be told.

She was born in Greece, had only a 3rd grade education, survived the Great Depression, married a man she loved, came to the United States at the age of 40 and started a new life with my dad, my two brothers and me. She worked at a candy factory until retirement. She loved her job and her friends there. She has been an unbelievable wife, mother and grandmother. Her big heart extended beyond her family in anonymous philanthropy to the ministries she believed in. She loves God and can still recite the Greek Orthodox Liturgy. Her mind has forgotten many things but her soul remembers her faith.

When my mother came to live with me after my father's death, I became very involved in the Alzheimer's Organization. Our family didn't know much about the disease but we learned through tears and pain how to move forward and care for our mom.

The journey I have been on with my mom has changed my life forever. I see how delicate life is. I know that in spite of how it might appear, her soul is alive and responds to a hug, to a touch, to someone just sitting with her and asking her about her life as a young woman. She loves conversation, yet people are afraid to converse with her because with Alzheimer's the assumption is that she won't remember anyway. Or even worse, that the disease is contagious.

Through the trials, tribulations and heartache of mom's disease, we have created the George & Dimitra Vlahos Foundation (GDV Foundation.) The Foundation's mission is to bring awareness to and fundraising for the elderly. We will be giving yearly scholarships to qualifying students. As one of the criteria for qualification, students will be required to have completed a project about how they have enhanced the life of an elderly person.

Today, mom spends her days lounging in her recliner like a cat in the afternoon sun, eating French fries and savoring chocolate. She is loving her life surrounded by her loved ones. We are grateful to have her, for we know the memory may be gone but the soul is alive!

Fearless Vision:

When we look into the souls of others, we see not only them, but ourselves as well.

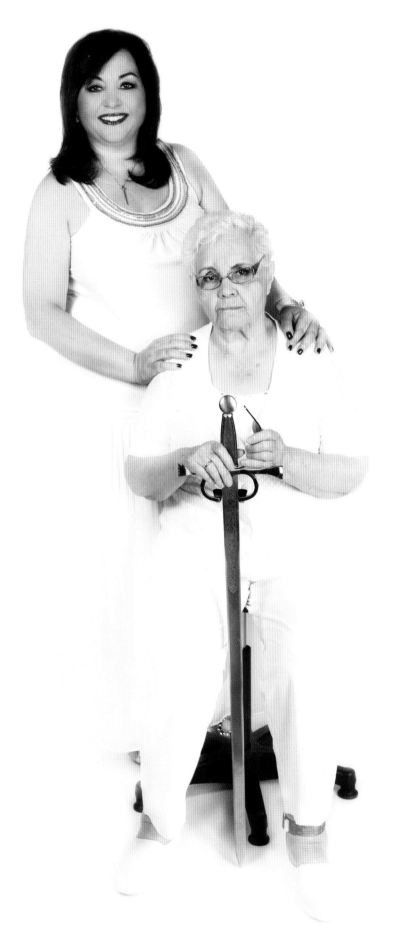

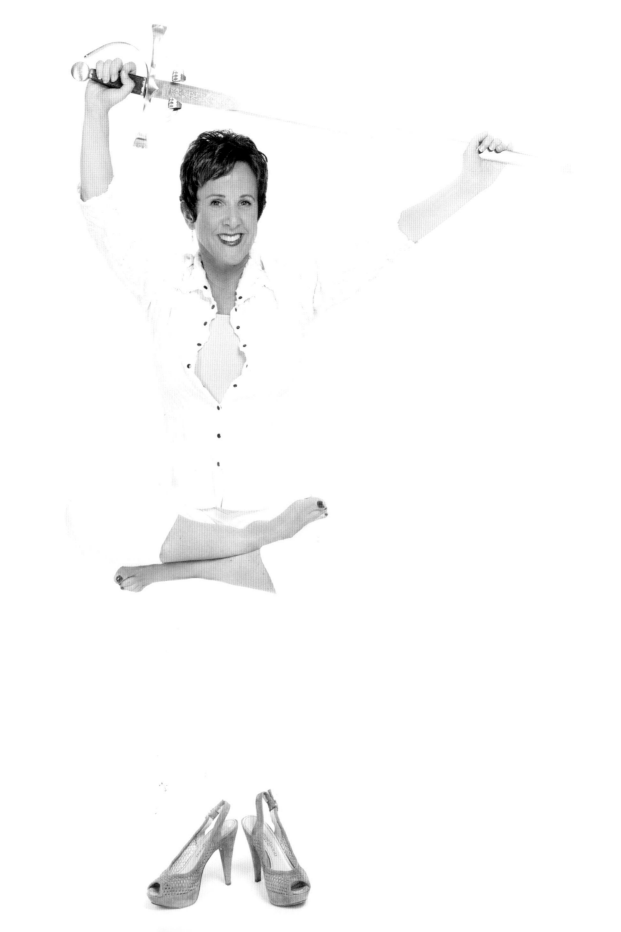

The year I was born, my five-year-old sister Audrey, lost her hearing. As she grew older, her illness became worse, causing blindness. It's the story in my life that formed who I am and what I do. Although I don't recall the details, I know my parents lost their faith and somewhere along the way I began to value dreaming. I used to joke, calling myself, "Susie Hope."

Over the last three decades, I founded Dream University® and wrote 14 books on how to achieve your personal and professional dreams. I appeared on Oprah several times and addressed audiences of thousands of people. And yet, something was missing. It turned out that the person I most needed to be seen and heard by was my sister but that wasn't going to happen on a stage or TV.

There are the dreams we have for life and there are the dreams life has for us. I believe everything we live through, our greatest successes and most painful losses mold us to be uniquely us, encouraging us to live on purpose and in integrity with our soul. So, the question becomes, "What's important to you and what are you willing to do about it?"

This year, I am committed to helping one million dreams come true. Although many would say this is a time to be realistic, I believe it's never been a more important time to dream. Connected to our dreams, we are empowered and in control of our destiny. Dare we say, fearless? A world that dreams has hope and in that state, miracles occur. We could see world peace, food, water and education for all. We would usher in joy, love and abundance, our natural state as creative visionaries.

In leading a Dream Movement, my life's work is about restoring dignity through clarity, courage and confidence. This dream work is currently taught in battered women's shelters, prisons and corporations.

What's your dream? I encourage you to prove to yourself and the world that you are not just thinking, talking or dreaming about your future. Show that you are more committed to your dreams than to any doubt or fear, by taking action today.

Where are you looking for evidence on whether or not your dream is a good idea? Don't look in your checkbook or on the news or in someone else's eyes. Prove you believe in yourself and your most heartfelt dreams by taking action today.

Fearless Vision:

Believe in your dreams not because there are guarantees, promises or assurances, but rather because they matter to you.

LINDA GRAY

In July of 2010 I was blessed to go on a trip that would change my life forever. I had never been to Malawi, Africa, before and I honestly had to look on a map to find out where it was. I accompanied a delightful group of people with an organization called Force for Good that's devoted to bringing food to developing countries. We were delivering bags of food that would feed a child for a month.

Before we left for Africa, I went to my grandson Jack's school and showed his class where Malawi was on a map of the world. It's a tiny country near Zimbabwe. Then I showed them a DVD of the area I was going to visit and served them a pot of the same food that we were going to feed to the children in Malawi. The students were mesmerized by the Malawi children's faces, and also by the fact that everyone in Jack's class had eaten breakfast, lunch, and would go home to a lovely dinner.

How could other children go hungry? They couldn't understand.

When I arrived in Malawi I handed out bags of food to the waiting children; I helped their mothers cook the food on an open hearth, and gave the children the bags of food that would provide enough food for a month.

On my second day there, I was walking through a very small village down a long dirt road. A little boy came up and took my hand. We walked silently for a while and then he said, "Lady, do you have a pen?"

"No," I said. "I'm so sorry but I don't have a pen, Sweetheart."

He was silent for a moment and then said, "...because, lady, if you had a pen, I could go to school."

My mind raced back to my grandson's class and reflected on how much we have, how much we take for granted... but a simple pen was all this boy wished for so that he could go to school.

So much to be pondered. So much to be grateful for.

Those children in Malawi will be changed because of the food they received, but who was changed forever because of looking into their eyes and seeing their smiles? Clearly it was I.

Fearless Vision:

The Pen is Mightier than the Sword.

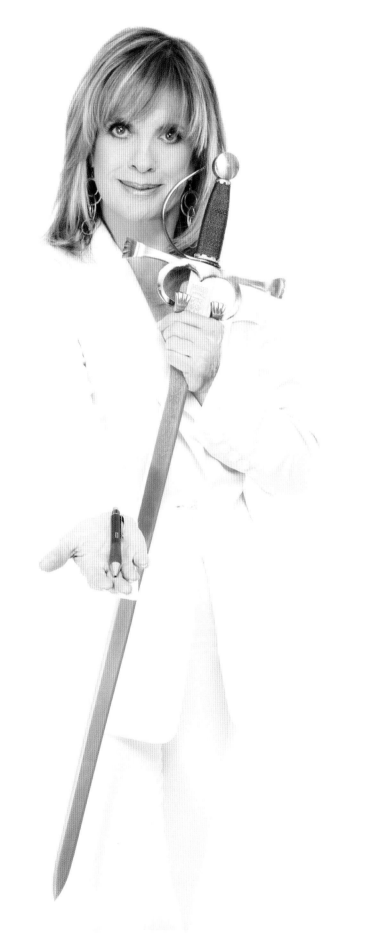

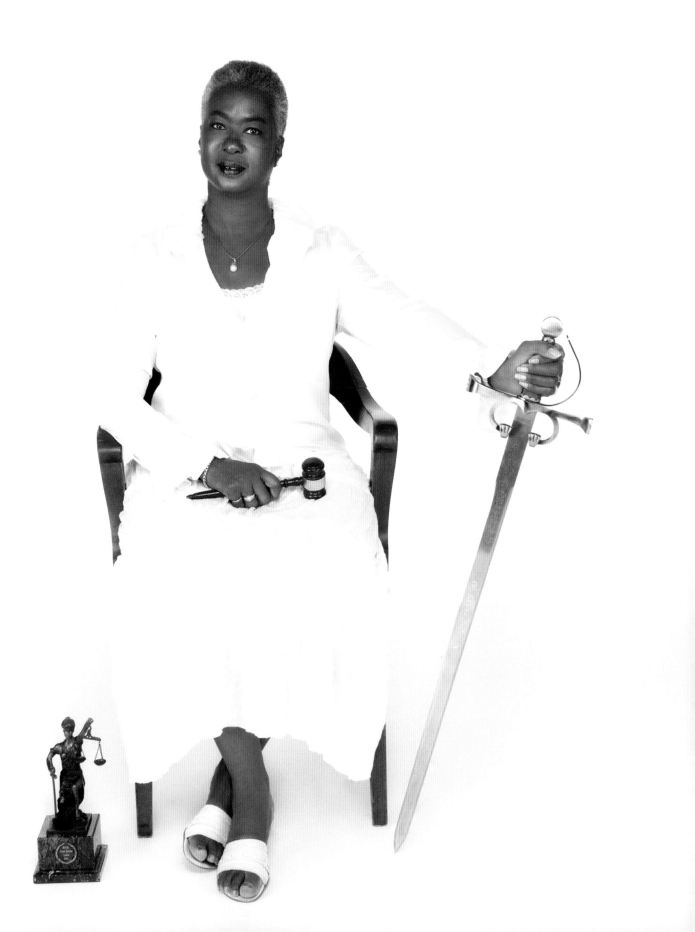

JUDGE PAMELA G. ALEXANDER

At the age of twelve I witnessed the vicious rape of my best friend. I knew the world had to change. I knew I would be a part of that change. But how could a poor African-American girl, the youngest of five children whose parents did not attend college, change the world? Be a lawyer, I thought. They help people. They have knowledge about how things work. Maybe that could be my vehicle of change.

As I looked around, I saw few lawyers who looked like me. That only intensified my commitment and determination to give back. My journey to that goal was filled with luck and blessings and an indescribable pride to have become the first person in my immediate family to graduate from college.

My career began as a criminal defense lawyer at a small community law office called the Legal Rights Center. Following that, I became the first African-American woman prosecutor in the Hennepin County Attorney's Office, specializing in the prosecution of sexual assaults involving children. In a full circle moment, I had the pleasure of successfully prosecuting the very person who years earlier had raped my best friend and putting him away with a long prison sentence.

Was I fearless through this? No, but I did have the conviction to stay the course and the courage to step up. I knew I had more to do and "The Lord wasn't through with me yet!" In 1983 I became the first African-American female Judge in the State of Minnesota and served on the bench for the next 25 years.

My most famous decision, the State of Minnesota versus Gerald Russell held that the penalties between crack and powder cocaine had to be equal. The inequities in application violated the equal protection clause of the Minnesota Constitution and unfairly discriminated against African- Americans. One year later, that case was upheld on appeal by the Minnesota Supreme Court. In 2011, after a 20-year battle, it was applied nationally to all cases involving crack and powder cocaine.

I left the bench almost four years ago to head the Council on Crime and Justice, a non-profit agency dedicated to supporting victims of crime and helping offenders re-enter society. I continue to lend my voice to change the criminal justice system for the better. Fearless, I don't know, but courageous, definitely.

Fearless Vision:

My vision of a new world is where each of us contributes to the uplifting of others to make a better world for all.

LINDA RIVERO

I sit in my customary position, at her thick ankles, colorful yarn twined in my wee fingers. My pink crochet hook dances stitches nimbly on heavy wool while she spins gossamer-fine cotton into bedspreads and tablecloths of museum-quality craftsmanship. With tiny hands moving in rhythm to the lilting melodies of the southern Italian mountains of her youth, I hum along, smelling the burning wood and spring foliage of her girlhood as I sing.

This was life as I knew it, through her eyes: fragrant, cruel, chaperoned, painful yet warm, colored by ethereal visits of loved ones gone and golden hopes for a new beginning. These stories, songs, and spirits flourished in the garden of my childhood.

A fearless woman she was, as is her daughter, my mother, Maria Assunta (literally Mary of the Assumption), known in America as Susan.

I am from them. I, too, am a fearless woman. I know nothing different.

A Fearless Woman is Every Woman. We recognize each other by the inner fire alternately ebbing and roaring, eternally alive and expressing itself as instinctive healing, reflexive caring, and fierce harmony.

Our fire drives us to need and to care, defying its counterpart: Fear.

Fear propels me! ...to echo throbbing African chants and lyrical Brazilian ballads in my song, to hurl my hips to the djembe's rhythm in my dance, and to reverberate life's tenderness and fire, always.

Fear defies me, driving me to devote my time, heart, and creativity to linking minds and souls across the illusory boundaries of differences, to bond with my sisters and brothers, be they in Detroit or Dakar, Rio or Rome.

Fearlessness is my core, as I bring Western women – who are often filled with trepidation – to African villages where they give and receive, learn and teach with our African counterparts, discovering a profound Sisterhood previously unimaginable.

The Fearless Woman knows no boundaries. A fearless future beckons us, dazzles us with brilliant possibility of a new world: a New Earth thriving on the harmony of our collective life-song, vibrating with the rhythm of our shared laughter and the lyricism of our Oneness.

The Fearless Woman sees this light, this brilliance, this future. She gifts all of life with her tenderly fierce touch of compassion, balanced by intuitive intelligence.

Fearless Vision:

Fearlessness takes me home, to the World and the Oneness I find always in my singing, and everywhere I go.

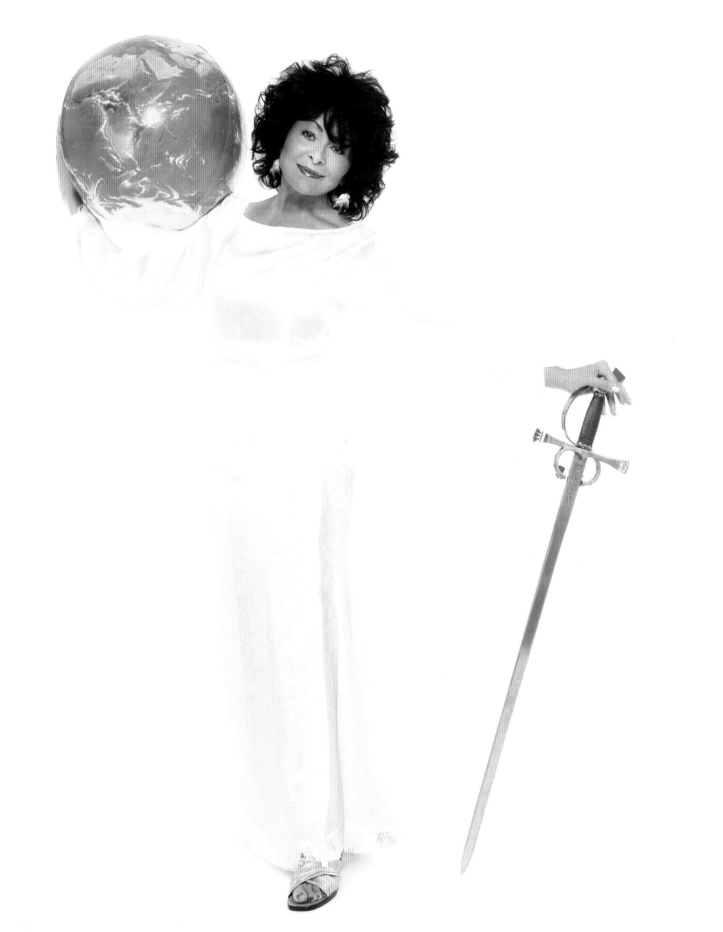

NICOLE JACKSON JONES

Growing up a non-Mormon in Utah made me comfortable not fitting in with the "norm." Years later this skill became very handy when my 11-year relationship ended and I found myself exploring the brand new world of the divorced single mom. Rather than questioning what to make my husband for dinner, I had far more challenging conundrums: How to get along with my ex-husband and his hot new wife, and how to be "in" with all the moms at school when I was the only "divorcee" in the bunch. Not to mention, where the heck was I supposed to find this elusive superhero known as "Mr. Right" at this stage in life? And perhaps most importantly, who should I have sex with in the meantime?

I posed these questions to my 77-year-old grandmother who has always been my moral compass, and even this wise sage couldn't come up with any answers. No one could!

I began doing stand-up comedy so I could pose these questions to a broader audience.

While touring as the opening act for several A-list comedians including Last Comic Standing winner Alonzo Bodden, I found out there were a lot of women (and men) experiencing similar challenges, yet feeling sorely neglected by today's mainstream media.

So I started a website called "Twisted Broad" which opened the door on these topics in a funny, irreverent way. Within months my most popular video blog, "Men's Size and What We Women Would Like Ya To Do!" had almost 100,000 hits on YouTube.

Slowly I saw that my unfiltered approach to sex, relationships, modern-day morality, and parenting wasn't just helping those who choose not to live the "white picket fence" lifestyle, but also happily-married couples.

As I discovered wonderful ways to get along with challenging people from my past, I also began to get along better with everyone in my present. Needless to say, this forgiving, carefree, easy-going attitude is a million times more appealing and FUN than bitterness and desperation!

And as far as Mr. Right goes, I've let go of that old fantasy. I have a new and better dream involving hard-earned independence and freedom that allows me to explore my life – including my sexuality – in ways I never before imagined.

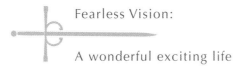

Fearless Vision:

A wonderful exciting life is what can happen when all of the dreams you thought you wanted fall apart.

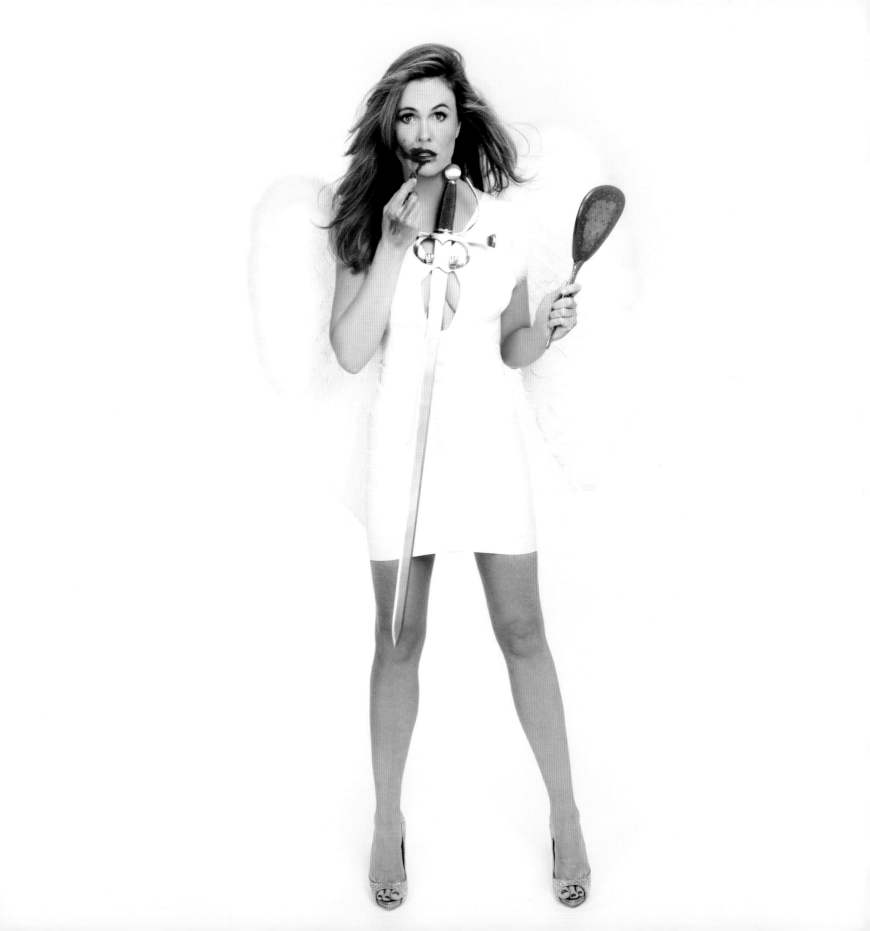

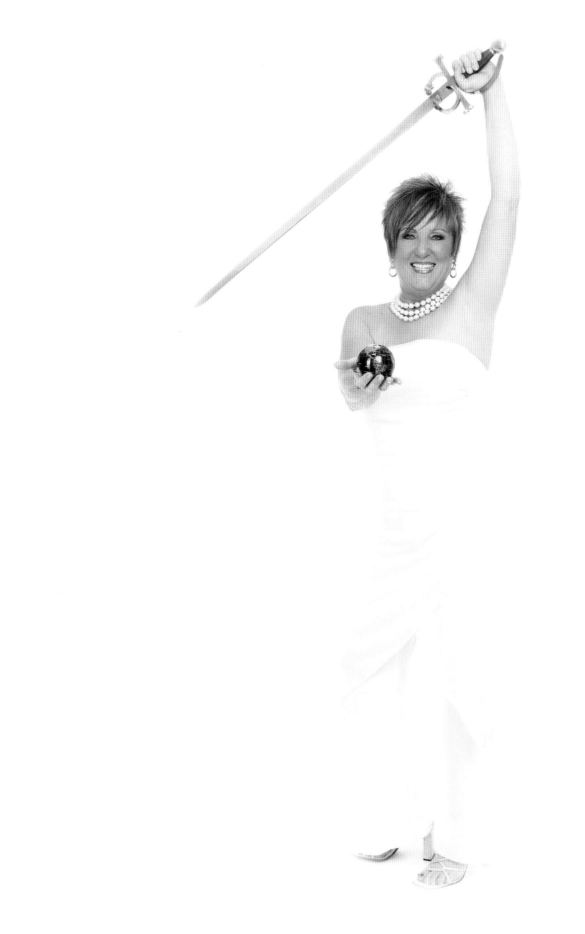

PAIGE BEARCE-BEERY

If there's anything I know for sure, it's that the only barriers in life are those we create. We come into this world as pure love and unbridled energy. As we live life, our experiences and circumstances begin to dictate how we see ourselves. This does not always serve our highest self. We can become burdened by negative perceptions because at our core, we believe them to be true. Once we become free of our self-created limitations we can live in peace, joy and creation.

Twenty years ago, while the world would say I was living a life of success, in my reality, inner peace eluded me. I had become my job. At that point, and there are no accidents, dear friends approached me with the idea of experiential work focused on "at peace" living. My intense quest began as a "founding mama" of Live at Choice - workshops that are designed to discover life's pure essence through a process of facilitated self-exploration.

Over the next fifteen years I was actively involved as we supported countless people, ourselves included. This meaningful work continues today. I am clear that my commitment to intense self-work has created amazing realities including a robust twenty-seven-year marriage, a twenty-three-year career in a single industry, the purchase and management of three successful businesses with my husband/business partner and innumerable rich, lifelong friendships and family experiences.

Those in my life know me as a successful entrepreneur, international business owner, leader, caregiver, creative chef and family fanatic. I am a woman with an intense passion, infectious spirit and am perpetually energetic and enthusiastic. It's not uncommon to hear, "I'll have what she's having!" This zeal has rewarded me with a blessed and abundant life.

Such a challenging and rewarding introspection revealed tools that helped me develop a capacity for choice. It has enabled me to create and design this life I love and relish. I invite you to consider, choose and embrace what resonates with and empowers you. Appreciate being present in the moment, not caught in the future or past. When fully engaged in the moment, life unfolds richly with depth and satisfaction. Commit to living each day without judgment. Develop strong meaningful relationships with family and friends. Think powerfully, create, believe and engage. Choose to live passionately and you will be rewarded with a life of endless Joie de Vivre y Pura Vida!

Fearless Vision:

The power of living life in joy and love can transform humanity, opening the way to a world truly at peace.

LISA LARTER

Teaching people to see the possibilities that exist through the use of technology. Demonstrating how to leverage their social networks and create the life of their dreams. That is my passion.

I grew up in a small rural town in Northern Ontario. Raised by my mother, I learned at a very young age about the inner strength a woman can possess. We were poor, very poor and I knew that in order for my life to change I would need to leave that small town. That was 1988.

Nine years later, I began my career in the wireless industry where I developed a passion for technology, the greatest equalizer of mankind. No matter what your economic upbringing, if you have access to a computer and the Internet, your world is full of opportunities. I was driven to teach all it had to offer.

Not only is this a new world of entrepreneurship and opportunity – it is a new world of social responsibility where one tweet or Facebook status update can move hundreds or thousands of individuals to donate and support a cause.

Once upon a time we were disconnected. Today, we are connected like we have never been before. Our ability to get a message out to the world, our ability to access almost anyone, is at our fingertips – we just have to know how.

The gap between not knowing and learning these skills is very small. Often, it is the influence of another person who can spark opportunity for you. I want to empower women everywhere to accept this opportunity, to embody this opportunity, to guide them in creating the change they crave for their world, their families and themselves. The law of reciprocity is alive and as the world shifts to a new place, more and more people are stepping up and out to help others create what they want and need in their lives.

Fearless Vision:

I envision a world where everyone has access to technology and has control over her own destiny!

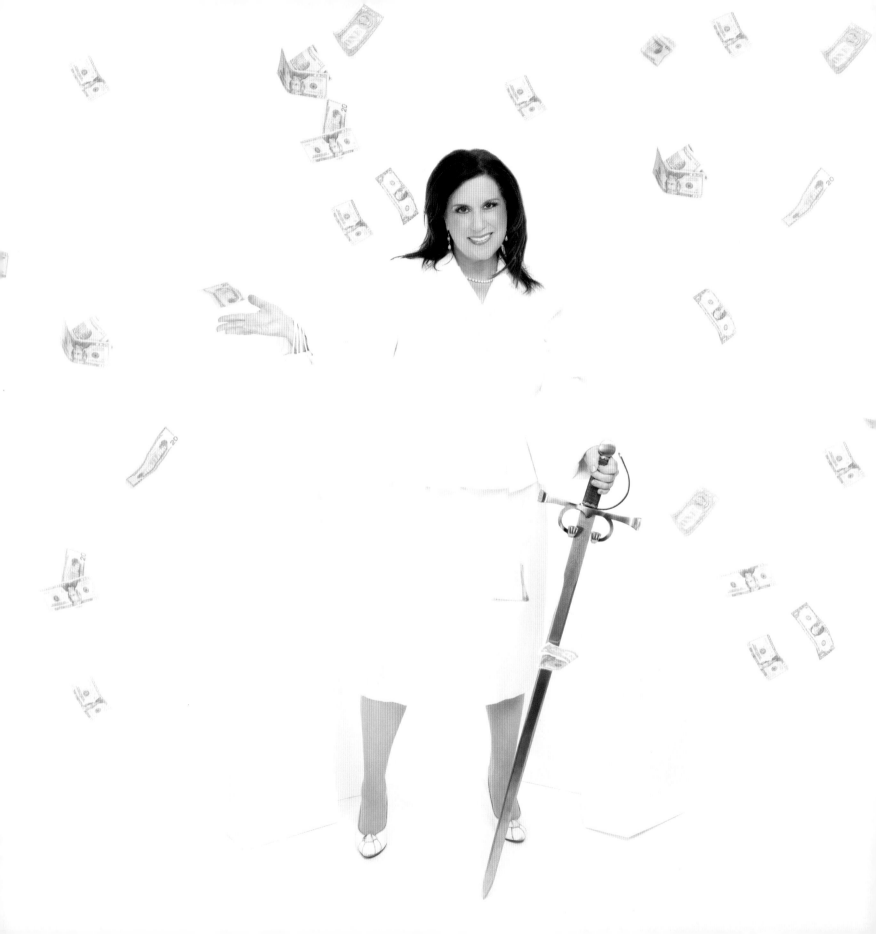

LINDA HOLLANDER

Once upon a time I was living in a rent-controlled apartment and working at a dead-end job. In my personal life, I was in an abusive relationship and the poverty trap for years. I was worse than broke. I was afraid to go down to my own mailbox because there were bills lurking there that I could never afford to pay. My hand would shake as I opened the mailbox door. It was a constant reminder of my financial failures.

I was also short with frizzy hair.

One day I had an epiphany and knew that I didn't want to be a victim anymore. At work my boss said he would be sharing my office with me. This meant I would be reduced to working in a fish bowl for 8-10 hours a day. I would lose my privacy completely. Then my boyfriend and I went to New York together where he was verbally abusive to me in front of one of my friends. Girl Power saved my life because my girlfriends gave me the strength to leave this abusive man and quit my job. I chose freedom and empowerment.

My best friend Sheryl Felice and I joined forces and used our Girl Power to the max. We launched a packaging business which sells custom-printed shopping bags to leading-edge companies. That's how I became known as the Wealthy Bag Lady.

Our fledgling business became profitable in a very short amount of time. I met many entrepreneurial women and discovered I had a talent for understanding what motivates them and how I could help them increase their success.

Through learning how to start and succeed in business, I was able to pay my debts, quit my dead-end job, and dump my abusive boyfriend. I met a kind and gentle man named Leslie who is now my husband. He is a constant source of love and support in my life.

By far the most important thing I've learned is to never let anyone else's opinion of you become your truth. I've been told that I couldn't start a business, yet I've started five of them and I now have over 20 years of experience as a small business owner. I've been told that I couldn't write a book, yet I authored a #1 bestseller. I was in an abusive relationship in which I was told I was fat, ugly, and stupid. Today I'm in a wonderful marriage with a man who thinks I'm smart and beautiful.

I'm still short with frizzy hair – and hundreds of hair products.

Fearless Vision:

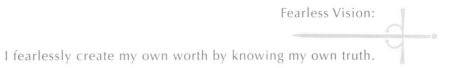

I fearlessly create my own worth by knowing my own truth.

Naomi Ackerman

In the bathroom of the house I lived in as a child, there was a three-section mirror. When I opened the side mirrors just right, I could see my reflection many times. I used to sit on the edge of the sink for hours, singing, talking, fascinated by the many faces of myself, looking back at me.

I became an educator, an activist and after that, an actress. I wanted to use the stage to create the world I dreamed of – a world where kindness prevails; a place where you can remove the mask and speak from your heart. Theatre has the power to give a voice to the silent, to be the voice of injustice, the voice of change.

The path from my core Jewish values to activism was short and direct. In my home, my remarkable parents didn't just talk about social justice, they lived it. They raised me to care because that's the right thing to do.

Fifteen years ago, while part of a women's theatre group, I was commissioned by the Israeli Ministry of Welfare to write a monologue about a battered woman. That monologue, which turned into the performance piece, *Flowers Aren't Enough*, took me on the most surprising and rewarding journey of my life.

After more than a decade of performing *Flowers*, I realized that I am the reflection of the abused woman I interviewed. I represent those who have been hurt. I am the voice of those who cannot speak. It is the reflection of the untold story that keeps me going, the strength of these women's weakness that touches my soul. I never planned to be the Domestic Violence Queen or the Relationship Lady, as I have been called. I too, have been guilty of settling for less, even though I was told I was worth more.

I was moved to found the Advot (Hebrew for ripples) Project because like a ripple, communication, kindness, love and change start small and grow. The women I met globally, activists in Israel and the West Bank, my beloved incarcerated youth in Los Angeles, taught me that the human spirit, if given the chance, has the incredible power to soar to the heights. I have seen laughter, joy and song in the darkest of places. It is there that I understood you must own and declare your self-worth and **never** give it away.

Fearless Vision:

I dream of a world where people realize their self-worth; where they believe in themselves, even if they have never been told that they are worthy.

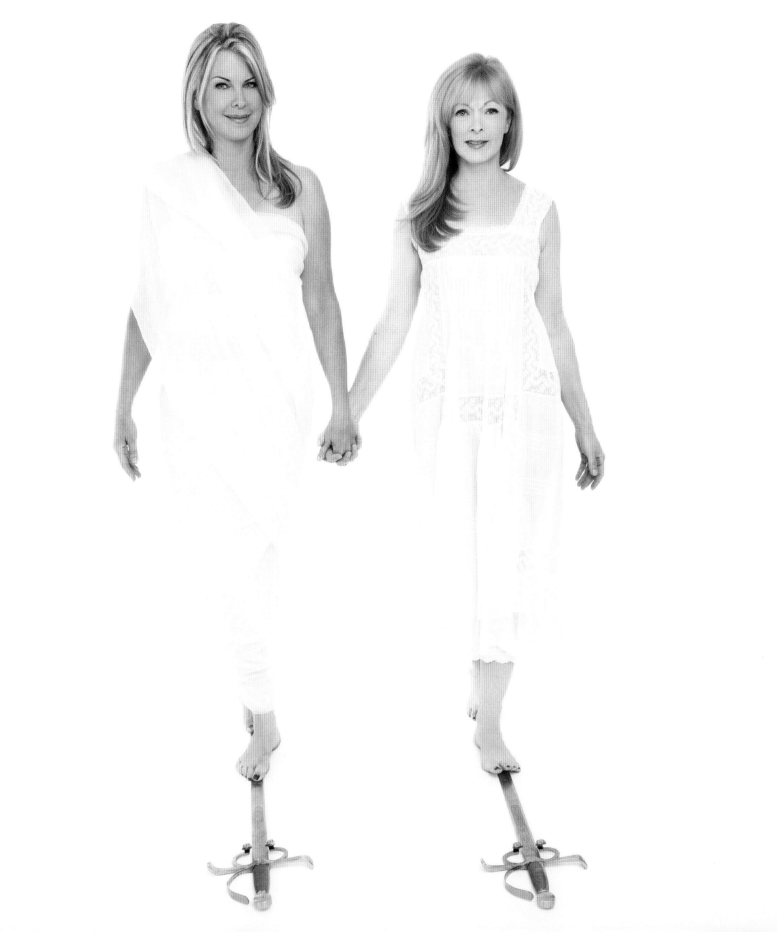

REBECCA GRAY GROSSMAN AND FRANCES FISHER

Rebecca Grossman: Growing up in Texas, I never would have imagined that one day I would find myself with a young Afghan girl who was severely burned and horrifically disfigured, soaking her in a bath of emollients to soften her scars, zipping up her compression garments at bedtime, and adjusting her face mask designed to flatten the severe scars on her face... a daily ritual.

My husband is Dr. Peter Grossman, Director of the Grossman Burn Centers and the surgeon for young Zubaida Hasan. Peter and I had become the legal guardians for this child and cared for her, on and off, for seven years. In 2006, inspired by Zubaida's strength and educated by her plight, we launched The Grossman Burn Foundation, an organization of humanitarians unified for a better world.

As the foundation grew, each initiative sprang up like a well of water breaking through the surface of untouched soil as we journeyed forward guided by Zubaida's spirit and her determination to have a life, to be respected, to overcome tragedy, and to learn to cope with lifelong scars.

Today our foundation has created programs to support training and provide quality healthcare in remote areas of the world using new technologies such as telemedicine. We've published a Humanitarian Assistance Manual for worldwide distribution, developed Project Faith, a program to support burn survivors, and launched a campaign to Stop Violence Against Women Globally, including a trauma recovery program for Afghan women.

Every day we are grateful to have had the opportunity to know Zubaida, and every day we are learning how we can better support others like her who come into our lives. Crossing paths with actress and burn survivor Frances Fisher was yet another example of divine intervention. Frances and I have found ourselves joining hands and hearts while creating visions of a new world.

Frances Fisher: When I was healing from my burn wounds under the care of the brilliant doctors Richard and Peter Grossman, an angel walked into my life. It was Rebecca Grossman. Rebecca's positive energy and fearless determination to make a difference in her world inspired me to do more in mine.

A Course in Miracles says, "Where would you have me go, what would you have me do, what would you have me say, and to whom?" I live by these words, walking my path in gratitude, with my many sisters by my side.

Fearless Vision:

In fearless sisterhood we walk the blade of courage and change the world.

Lorelei Wolter Kraft

Anything Is Possible! Not only is that my life philosophy, but it is also the title of a book I wrote that shows the immense capabilities of ordinary women. In my world vision, women must be accorded equal rights not just because we are as capable as men but because those rights belong to every human being.

The world talks equality, but doesn't practice it. Look at pictures of world leaders gathering at summits. These are the people deciding our lives—yet there are almost no women in those photos. Women do not share in political, economic or social equality. Even in the U.S., women are only 16% of Congress, 12% of the governors and 5% of the CEOs of Fortune 500 companies. Many churches still teach that women are inferior. Equal rights should not be determined by the shape of one's skin!

Why is it important to include women in decision-making? Ask a woman if she wants the government budget spent on "butter" or "guns," her priorities are for butter. Women are slower to put our fists up to solve problems and work better in a team atmosphere. But our softer way of coming to consensus and our insistence on basic human priorities other than war, like education and health, are brushed off. Women are more than 50% of the population, yet have little real input in decision making and unfortunately are not insisting on taking our rightful place in the halls of leadership.

 A simple way to change the attitudes toward women is to start with changing language. A "man" promoted to vice president is perceived as having power; the "girl" promoted to vice president is seen as a weaker version. Yet many women want to be called "girls." Do we need to accept the subliminal messages we are continuously bombarded with in the media that our value only lies in being young—when our vision is so much greater?

Being fearless means speaking up when others remain silent. I write editorials, I speak, I coach, I mentor. I produced a documentary, "Five Weeks and Five Days," which shows the awesome power of what ordinary women can do when we work together. I try to always reach back with a helping hand to lift those coming behind. Sometimes it can be as simple as offering a smile.

Fearless Vision:

We can all be candles lighting other candles, for we lose nothing of our own radiance by lighting the life of someone else. And by doing that we can change the world for all human beings—including women!

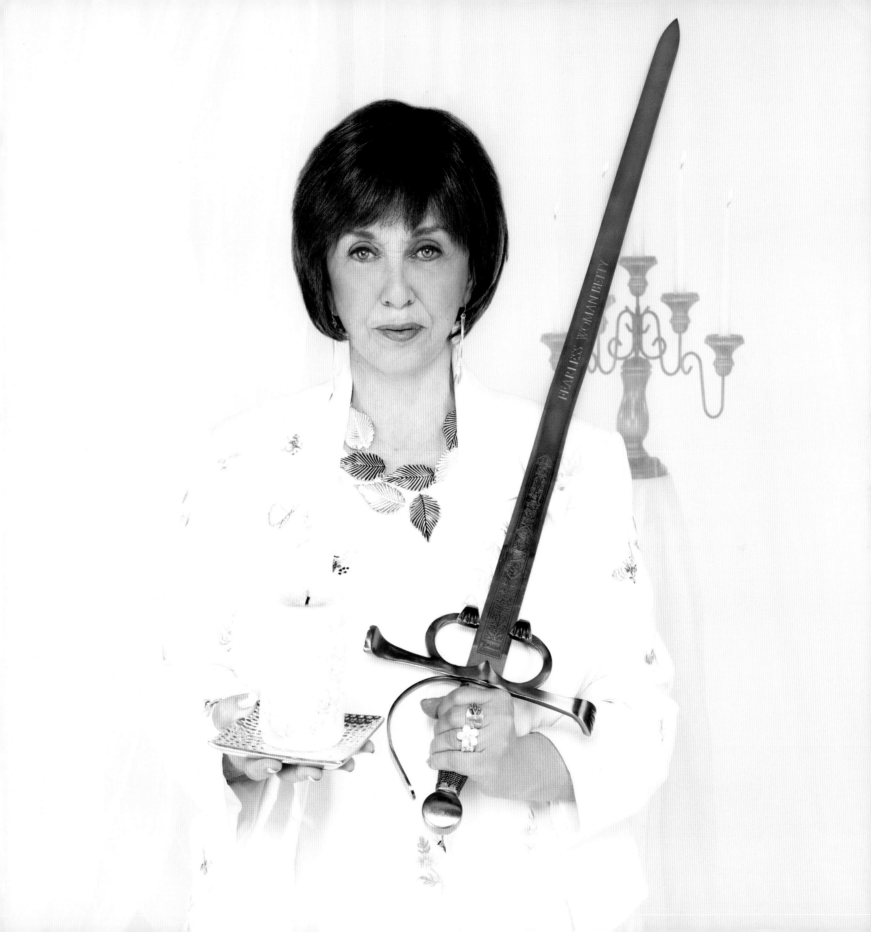

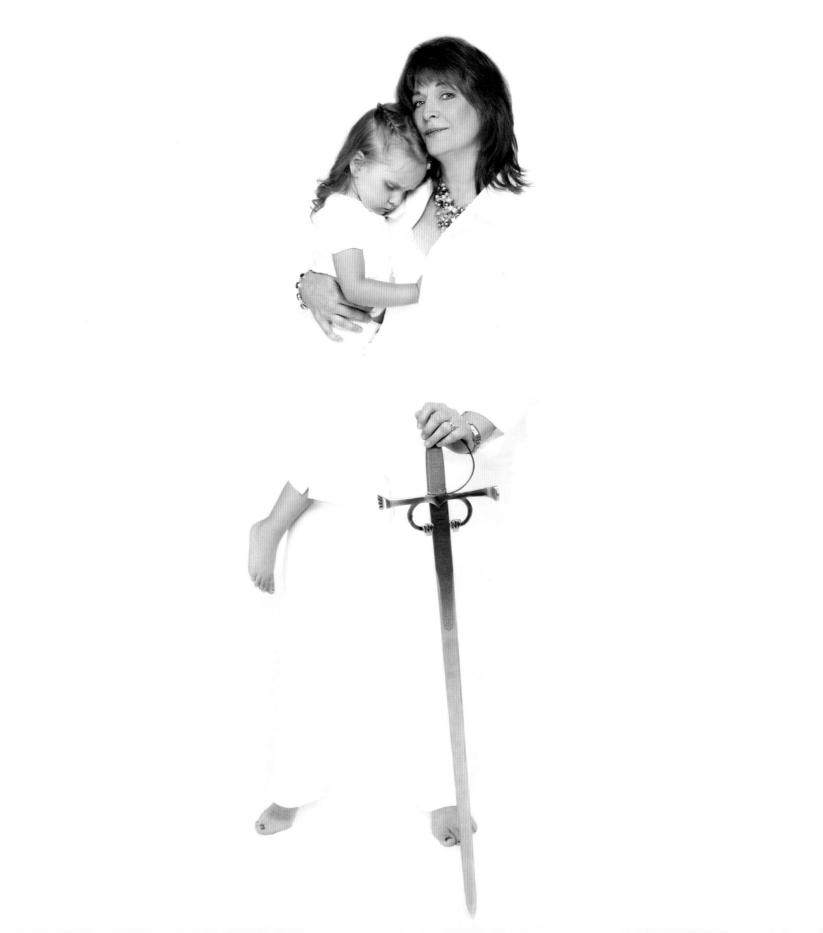

Mary Jo Sherwood

Never in my wildest dreams did I imagine I'd be fighting for the health and well-being of a grandchild I wouldn't meet until she was eight months old. When we are thrust into situations that we never expected to be in, the way we deal with those times is a true test of character.

My granddaughter's name is Lily. Her father, my son, has Asperger's Syndrome. Her mother has Fetal Alcohol Syndrome. As a result, Lily has been shuffled from place to place with no permanent place to call home. She's been exposed to things a child her age should never have to experience. Sometimes her mother has had no diapers to change her, nor decent food to feed her. I've learned more about the welfare system and custody laws than I care to know. As her grandmother I've had limited ability to influence her life, but I make the most of every precious moment.

I grew up in a family of five kids. My father traveled a lot and I wasn't always my mother's favorite. However, I was fortunate to have a couple of teachers and a few neighbors take an interest in me. They fostered my well-being and encouraged my success. I am so thankful to these adults for taking the time to share their insights and support, for giving me shoulders to cry on, and wisdom to help deal with the situations that confront any teenager.

I want to show my granddaughter that there is another world out there. A world where she can be safe and loved and succeed at whatever she puts her mind to.

Because of my granddaughter, I have become a Fearless Advocate for children. My vision is for a world where every child has someone in their life to mentor them. Not just kids with extreme needs and situations but all children.

I believe every child needs at least three adults in their lives in order to thrive and be successful. They need adults who will serve as healthy role models, who will mentor them and help them find proper perspective. If every adult would commit even one hour per month, think of the difference it could make – not just in a child's life, but in our own. Children are the next generation – they truly are our future.

Fearless Vision:

I envision a world where a child can be safe, and loved, and can succeed at whatever she puts her mind to.

MONA POLACCA

What makes me fearless?

When I was 14 years old, my mother, the late Edna Yumtheska Polacca, the granddaughter of Havasupai Tribal Chief Whatahomogie, and the "real" princess of the Havasupai Tribe, sat me down and gave the lesson of "Fearless Women."

She said, "You are not in this world for nothing. You are here for a reason; you have a purpose in life. Your life is not just you. You are an extension of me and your father; you represent our family, grandmothers, grandfathers, your brothers and sisters. Then you represent your community, your tribe, Native People and then, all the world. You must remember that everything you do in your life has an effect in many ways on more than yourself. Always be aware of how you talk, and walk your path of life."

These words have charted my life's path since then.

She also told me about the power of prayer. She told me, "Our old ways are very powerful. If you are going to use them, you must be honest and sincere. Our old people could communicate with the powers of nature. When you call on the Creator and the power of nature, your call will be heard. Pray to help our people."

As a member of the International Council of Thirteen Indigenous Grandmothers, I travel all over the world to visit the home place of the other Grandmothers. My children ask me, "Where in the world are you going? Do you know anyone there? Aren't you scared to go to a place so strange, so far away from home?"

My response is, "I am not afraid. I trust that the path I travel has been blessed for me by the good Creator and I will be safe, for good people will cross my path and I will return home safely. I am fearless!"

In my Native American spiritual practice one of the instruments we use is a staff (like the sword), whose point is in the earth. I hold that as a symbol of my connectedness to the Mother Earth and the Creator. Holding on to this staff is symbolic of my vulnerability and faith that this connection is my spiritual strength, giving me courage to meet the challenges one faces in life.

The connectedness of all of the life of this world supports me in my prayer. Thus, the colorful feathers of the bird carry the prayers through the air to the heavens.

Fearless Vision:

I trust that the path I travel has been blessed for me by the good Creator and I will be safe. I am fearless.

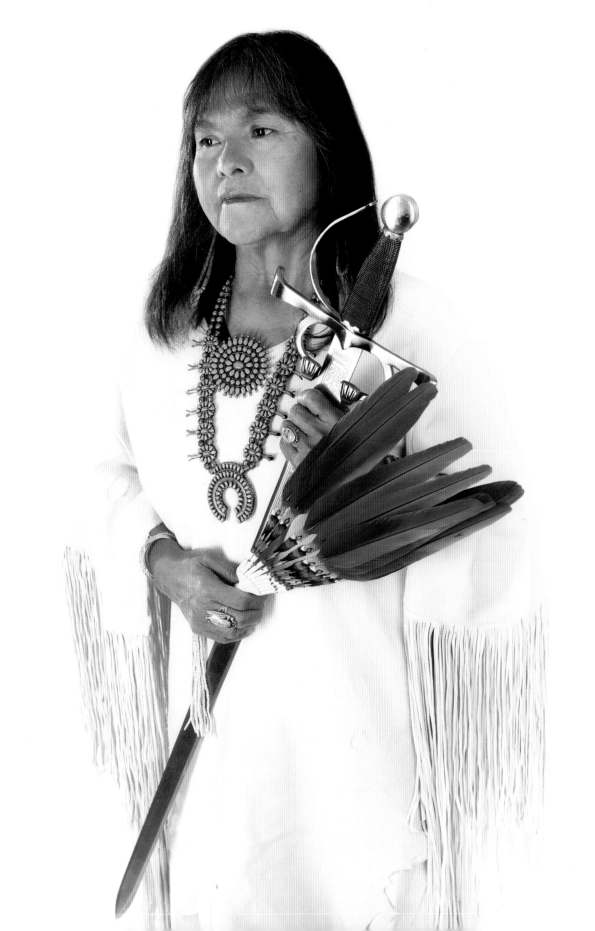

MARYSE SENECAL

"There is nothing as strong as gentleness, and nothing as gentle as true strength." ~ St. Francis de Sales

My mission is to support women in rebuilding their bodies, their spirit, and their heart. My work is about building strength. By strength I mean 'The Power Within' – core strength.

My passion is helping my clients build a strong backbone, which is the foundation of strength in the human body. The spine is the protector of life; it is the conduit for thought, action, and reflex. I help them build their backbone.

When women empower themselves with health and strength, they simultaneously begin to discover who they are; this is when we begin to accept ourselves fully; this is where we begin to believe in all of our capabilities. This is when we stand in awe of the power we possess. The greatest pleasure in the work that I do comes when the real work, which is the inner work, happens.

True inner strength is present when three elements come together to build the spine:

1. The Physical Core — This is where the work begins. Working with all of our body – especially those muscles that support the spine – teaches us to connect our physical being as one synergetic system.
2. The Spiritual Core — As the spine becomes stronger and straighter, somehow our spirituality comes to the forefront. We begin to question, to challenge, and to transform our beliefs.
3. The Heart Core — By far the most important, a strong Heart Core allows us to feel, to grow, to become all of what we are meant to be. We become fearless in the light of the power we possess.

We women hold the capacity for much of the world's work. Women have the ability to love and to forgive enough for all humankind. We are the vessels for creation, the "mortar" with which to build the foundation of the world's future, the children. Women are the very backbone of society.

Only when spirituality and love come together can we truly become strong. We have the power.

My vision is of women coming together in strength, positioning ourselves as the leaders of the world through love and compassion. I hear women gathering together in laughter, with resonant voices, accepting our weaknesses while embracing our strengths, and loving our differences as we co-create a new way of being, in understanding and acceptance.

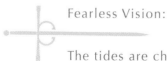

Fearless Vision:

The tides are changing. Women are becoming stronger in spite of the world, because of the world, for love of the world.

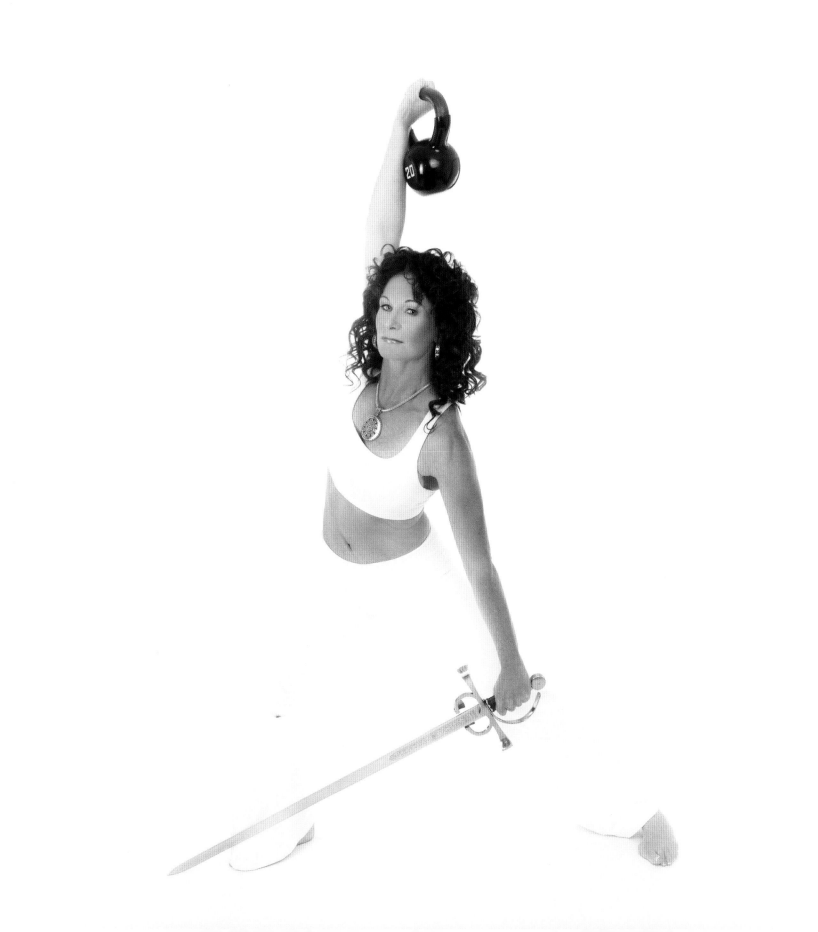

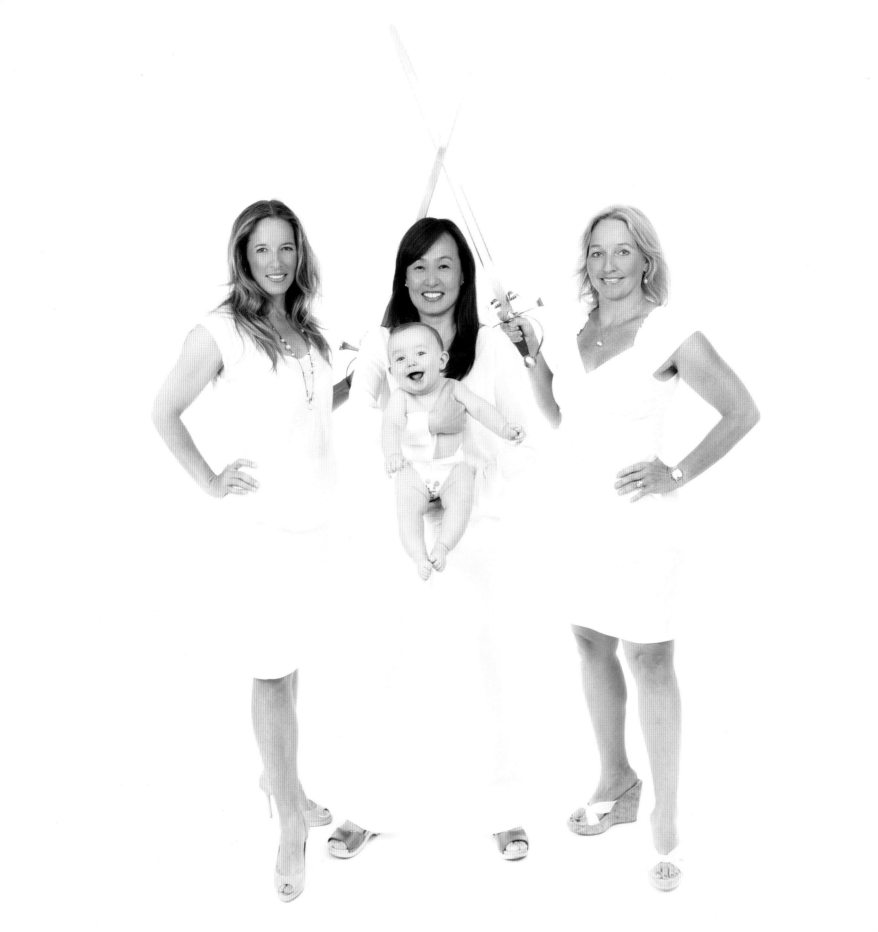

DR. ALLISON HILL, DR. ALANE PARK, DR. YVONNE BOHN

Health is beautiful. Forget the makeup, the plastic surgery, and the designer clothes. When you are healthy, beauty shines from the inside out. You have more energy, enthusiasm, and passion for life. You are a better mother, wife, and friend. Yet health is taken for granted by so many women.

We are gynecologists who seek to improve the lives and health of women every day. We do this in the obvious ways like evaluating their blood pressure, taking a Pap smear, and doing a pelvic exam. But we also hope to do this through the less obvious ways – by teaching women about their bodies, by accepting who they are, by listening to their intimate secrets and fears.

We are regularly amazed that many women do not understand how their bodies work and therefore don't know how to participate in their own health. We find that women base many of their health decisions on half-truths, myths, and other misconceptions that are passed to them through the media as well as friends and family. As gynecologists, we have the ability to educate women about their health – about everything from contraception to pregnancy to menopause. We dispel the many myths about hormones and infertility. We explain the truths about nutrition, stress, and depression, and how these affect well-being. We believe that understanding your body allows you to love your body in a new way. And loving your body leads to loving yourself.

We believe that simple things can change lives. We started The Mommy Docs Foundation, which is dedicated to bringing free preventive healthcare to women who could otherwise not afford to see a doctor. Many of these women are unemployed, self-employed, or do not qualify for health insurance. As a result, they do not have access to basic women's services, like Pap smears, pelvic exams, and mammograms. Through our foundation, we set up mobile clinics in underserved areas of the United States where women can receive these services at no charge. We hope to detect diseases in the early, treatable stage as well as to give women a safe place to ask questions about their health. We believe that all women deserve these opportunities.

We are honored that women entrust us every day with something so sacred – their health. They bring us their fears and insecurities, and we hope they leave with confidence and understanding. Empowering women with knowledge about their bodies is our greatest accomplishment. Empowerment leads to better health, to more happiness and to true beauty.

Fearless Vision:

Health is power.

MARSHA MERCANT

I used to have so many judgments of what was significant, worthy, valuable. I used to think because I hadn't built a school in a third-world country, cured a life-threatening disease or quelled the wave of poverty, that my contributions weren't meaningful.

My life as an artist has been blessed. I have traveled the world and met amazing people. I have performed for thousands. I have known tremendous success and heartbreaking rejection. And through it all, I searched for the significance of what I was doing. Often thinking it wasn't enough.

Last year that changed when my best friend of 45 years lost her courageous battle with cancer. We had performed together, lived together, laughed and cried together. And through it all, learned about life together.

When she passed from this world, I was changed forever by the joy of her living and the grace of her dying. She redefined my idea of what is significant. She made me understand that the simplest gesture, the awareness of someone else's need, a willingness to go even slightly out of my way has a rippling effect that not only impacts others but makes my own life so much richer.

Life's lessons never come in the pretty packages we read about in books and see in the movies. They are messy and painful and don't come with a how-to manual. They often come in waves. And just as we begin to recover from one, another comes to remind us not to settle for anything less than our abundant potential.

Six months after Melinda's passing I got that opportunity in the form of a death-defying car accident that literally and figuratively turned my world upside down. It reminded me how life can shift in the blink of an eye. I learned that it is when we stop looking for the breakthroughs that we can truly break through.

Melinda didn't know until the final week of her life how loved she was. How deeply she had influenced the countless numbers of people who came from all over the country to say goodbye. But she left this plane finally accepting the love, the admiration for her quiet, unassuming power. I want to know a world where we all feel that power within and pay it forward so that others will know it as well. When we say, "I see you. I hear you. I appreciate you. You make a difference in my life," *that* can change the world.

Fearless Vision:

Don't worry your life away waiting for the elusive prize at journey's end.
The journey is the prize.

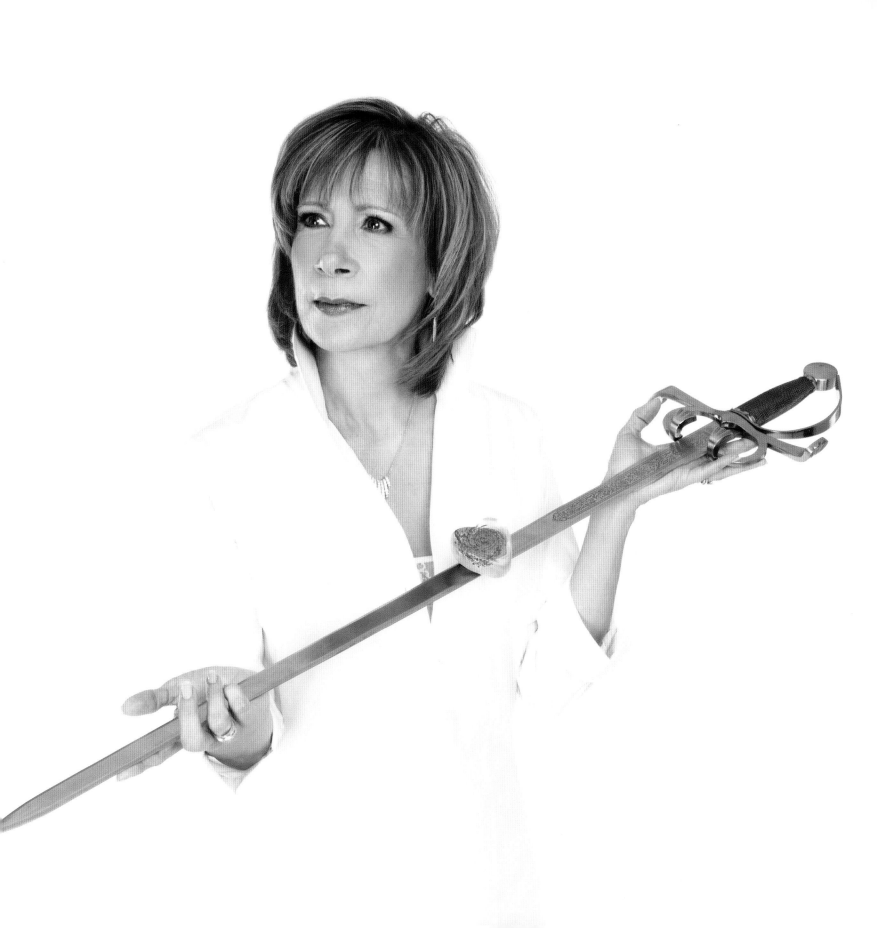

Mary Morrissey / Foreword
LifeSOULutions

Speaker, best-selling author, and consultant for over three decades, Mary Morrissey's transformational talks and seminars have made her one of the elite teachers in the human potential movement.

www.MaryMorrissey.com

Forbes Riley / p.14

I am a health & fitness expert, TV host, actress, author, keynote speaker, Inductee — National Fitness Hall of Fame, creator of SpinGym and proud mother of twins.

Forbes@MySpinGym.com
Forbes@forbesriley.com
727.954.7071

Makenna Riley / p.14

I have a passion for health & fitness like my mom. I love the SpinGym and how it helps women to get strong, and I'd also like to be a chef like my dad to cook healthy food for everyone. No one should ever go hungry or be sad and I'd like to help — does that make me a fearless daughter?

Susan J. Rosenthal / p.17
President, World Markets Group

I am a business consultant, Certified Corporate Speaker and professional coach.

World Markets Group is a general management and marketing services firm that maximizes the growth and profitability of organizations worldwide through industry expertise, experience, network and innovation.

susan@worldmarketsgroup.com
www.worldmarketsgroup.com
917.617.0546

Belanie Dishong / p.18
CEO and Chief Relationship Officer

I am an author, speaker, and course leader for Live At Choice, LLC. I show people how to uncover the secrets for greater mastery and empowerment of their relationships in life and business.

www.liveatchoice.com
www.facebook.com/Belanie
www.facebook.com/LiveAtChoice
www.twitter.com/BelanieDishong
Belanie@liveatchoice.com
281.859.0677 (o)
832.443.0549 (c)

Brandy Rainey Amstel / p.21
Living Powerfully, LLC

I am a creative entrepreneur, filmmaker and Living Powerfully talk show host. My mission is to awaken, transform and empower people to powerfully choose a life by their design.

www.LivingPowerfully.com
Brandy@BrandyAmstel.com
512.577.4954

Cherie B. Mathews / p.22
Inventor & Founder & CEO of healincomfort.com

I'm an 11-year survivor of breast cancer and inventor of proper post-operative equipment for women to heal in after surgery in their battle against breast cancer.

My patented "healincomfort" shirt allows our sisters in the battle to heal in comfort and dignity. No more men's dress shirts after losing their breasts. Women's bodies matter and deserve proper equipment.

www.healincomfort.com
HUB/WBENC/Certified
Facebook: healincomfort.com
healincomfort.com@gmail.com

Janet Grace Nelson / p.24
InSpiring Passion...EmPowering Change!!!

I am so happy and grateful to be living my Life with Passion and Purpose as an InSpirational teacher and coach to Encourage, Inspire & Empower others to live the lives of their Dreams with LOVE, Joy and Fulfillment.

www.JanetGraceNelson.com
www.facebook.com/janetgracenelson
janetgracegoddess@gmail.com
818.378.8663

Constance DeWitt / p.27
Founder, The Global Institute of Sustainable Solutions

Offering Business Development Coaching using the wisdom of Nature while educating environmentally conscious entrepreneurs by providing innovative sustainable products.

www.GISSconnect.com
Constance.gissconnect@gmail.com
Post Office Box 968
South Royalton, VT 05068 USA
800.437.8809

Patricia Connorton Kagerer / p.29
WIW Enterprises Inc.

I am the author of the book, Wise Irish Women, professional speaker and Certified Dream Coach® and a Construction Risk and Safety Expert. My mission is to be a messenger of peace in a chaotic world and to support women in claiming their power. A portion of the proceeds from Wise Irish Women will support my family's foundation to provide educational support for young women.

www.wiseirishwomen.com
Patricia@wiseirishwomen.com
Plano, TX
915.203.4518

Flora Mascolo / p.31

I am a philanthropist, humanitarian and founder of the *6thofmay* charity. My mission is to take the 6thofmay global and to represent those charities without a voice.

londonflower7@gmail.com
www.6thofmay.org

Jean Carpenter-Backus, CPA, CFP / p.32
The Naked Accountant
Carpenter & Langford, PC

Photo by Korey Howell Photography

I am a shareholder, professional speaker, author of "The Naked Accountant Asks: Who's Standing on Your Financial Hose?" The Naked Accountant tells the financial truth about money and how to keep more of it. She disrobes financial myths.

www.thenakedaccountant.com
www.carplang.com
Tax-rx@austin.rr.com
512.913.3157 (c)
512.795.0300 (o)

Dr. Doreen Granpeesheh, Ph.D., BCBA-D / p.35
CEO, Center for Autism and Related Disorders, Inc.
President, Autism Care and Treatment Today

I am a psychologist, behavior analyst, researcher and speaker.

www.centerforautism.com
doreen@centerforautism.com
19019 Ventura Boulevard, Suite 300
Tarzana, CA 91356
818.345.2345

Tracy Jo Hamilton, CMC, CCT / p.36

I am a Eudemonia Coach (human flourishing) & Intuitive Tutor, founder of Flourishing InsideOut, Peace-Making Circle Keeper, author and radio co-host of Universal Meaning Makers.I am a voice and an advocate for humans living life as a vocation,finding their calling for service of deepest meanings of human life—those of Goodness, Truth and Beauty. Raising our motivations in life is critical to bringing positive shifts in both our being and our behavior—thus, our experience of life is richer, abundant and ever-evolving. Our world is a better place when we are motivated and living by our highest potential for good.

www.flourishinginsideout.com
www.universalmeaningmakers.com
tracyjo@flourishinginsideout.com

Dr. Erica Miller / p.38
Mental Health Professional: Founder/Executive Director CDIF (California Diversion Intervention Foundation), chain of counseling centers.
Owner and Executive Director of MILLER PROP-ERTYS, Austin TX

I am author of the book, Thanks for My Journey: A Holocaust Survivor's Story of Living Fearlessly. Inspirational speaker with a mission to participate in TIKUN OLAM 'Healing The World.'

www.millerpropertys.com
www.drericamiller.com
drmiller@drericamiller.com

Teresa Surya Ma McKee / p.40
Integrative Synergy, LLC

I am a visionary, author, Certified Dream Coach®/ Spiritual Group Leader, Clinical Aromatherapist, Yoga, Meditation, Breathwork Instructor

IntegrativeSynergy.com
Teresa@IntegrativeSynergy.com
Lenoir City, TN
865.755.0778

Karen Fitzgerald / p.43

Hot Mama Mahatma (also the title of my solo show spiritual comedy about my trip to India)

I am a keynote speaker, desire coach, writer/actress/ singer. My vision is to help people embrace their dreams and step into their passion and joy to shine their light upon the world.

www.KarenFitzgerald.tv
info@karenfitzgerald.tv

Lisa Metwaly / p.44
Founder of Better Life Productions

I'm the Chief Instigator of Global Kinactor. I harvest traveling kindness and serve up what I learn to airlines, hospitals and schools. Vision: Kindness Everywhere! Mission: Create kind acts and ask recipients to pass it on; Connect kinactors to do group kindness during kindness week (first week monthly); Collaborate to expand the vision.

www.kinactor.com
Lisa@Kinactor.com
612.387.4977

Jolin Halstead / p.47
SOUL Purpose Parenting
Founder, CCW – "Chief Child Whisperer"
Soul Purpose Parenting ™, LLC

www.soulpurposeparenting.com
jolin@soulpurposeparenting.com
209.675.SOUL (7685)

Tamara Archer / p.48
Moms Health Zone - Simple Solutions For Great Health

I'm a speaker, health advocate and wellness entrepreneur. My mission is to restore and protect your most precious asset: your health.

www.MomsHealthZone.com
www.Facebook.com/MomsHealthZone
Tamara@MomsHealthZone.com
Twitter@MomsHealthZone
408.313.9094

Karen R. Mertes, Lt. Col. (Ret), USAF / p.51
President & Founder, Fulfill Your Destiny, Inc.

Motivational speaker, corporate consultant and philanthropist. My philosophy is based upon my belief that character drives destiny, and by embracing a values-oriented approach to business and life, one can achieve levels of personal and professional success never imagined. After surviving a traumatic, life-changing event, I founded a 501(c)(3) non-profit, Fulfill Your Destiny, Inc., dedicated to helping people whose life paths have been permanently altered.

karen.mertes@yahoo.com
karen@fulfillyourdestiny.org
Tampa, FL
813.831.1001

Tabitha Kyambadde / p.52
Founder of African Mission Outreach Organization

Photo by Rod Oman:
The Imagery Portrait Photography Studio

www.amoousa.org
Minneapolis, MN 55426
763.273.3999

Kathleen Hanagan / p.55

I am an ordained shamanic priestess, business mentor, psychotherapist, speaker, workshop leader, poet, and solo performer. I am a catalyst for awakening, helping women worldwide live fearlessly and fabulously. My Turn on Your Light Circles and programs show women how to turn on their full radiance as sacred, sexy and sovereign beings for the good of the entire planet.

www.Turnonyourlight.com: Sacred, sexy and sovereign
644 Sequoyah Drive
Waynesville, NC 28785
703.899.5855

Dr. Kathleen A. Hartford / p.56

I am an author, international speaker and licensed healthcare provider. My passion lies in creating harmony for the Mind, Body and Heart by bringing balance to the 5 aspects of health.

www.drkathleenhartford.com
www.drhartfordsnaturalpharmacy.com
www.sistersupport.com
dochart@healthpyramid.com
Pittsburgh, PA
1.800.893.5000

Dr. Shiva Lalezar, D.O. / p.58
I am a speaker and Integrative Family Medicine Specialist

Expert in Functional Medicine, Natural Hormone Therapy, Neurotransmitter and Nutritional Balancing, Heavy Metal Detoxification, Chelation, and Intravenous Vitamin Therapy.

www.healthandvitalitycenter.com
drlalezar@healthandvitalitycenter.com
11600 Wilshire Boulevard, Suite 120
Los Angeles, CA 90025
310.477.1166
310.477.9911 (fax)

Shelly Manougian, CFm / p.61
Bella Intimates Boutique

I am the owner of a multi award winning intimate apparel boutique, nationally recognized as a leading Bra Fit Specialist, and passionate about helping women find that perfect piece underneath and confidence within. Renowned for personal service, selection, and fit. Specializing in post-surgery items for women with breast cancer.

www.BellaIntimatesNH.com
www.facebook.com/BellaIntimates
shelly@BellaIntimatesNH.com
150 Lafayette Road
Rye, NH 03870
603.964.7775

Katie Meyler / p.63
More Than Me Foundation

I'm the founder of a non-profit that helps little girls get off the streets and into school in Liberia, West Africa. I'm a spoken word artist, iphone photgrapher and a motivational speaker. I share a message about living for something bigger in a world that is more than ready for change.

www.morethanme.org
www.facebook.com/katiemeyler
katie@morethanme.org
612.242.0967

Katie Laine / p.65
Certified Executive Coach, Leadership and Communication Specialist and Facilitator

My Purpose is to assist people to know who they are and to give their unique contribution in this life.

www.discoverconsulting.us
Katie@DiscoverConsulting.us
512.507.7777 (c)

Sarah-Jane (SunJay) Owen / p.66

I am a Medicine Woman, Healer, Earth Steward, Keeper of Songs and Ceremony.Powwow Lodge - Center for the Healing ArtsSpiritual Retreats & Workshops, Wisdom Teachings, Healing, Blessingways, Ceremonial and Sacred Gatherings

www.powwowlodge.com
sunjaymedicine@gmail.com
Pine Mountain, CA 93222
661.242.1779

Perfect 5th/The Martin Sisters / p.66

Perfect 5th is on a mission to aspire and influence positive change in the world through uplifting songs that will ignite and empower people to participate in a changing world.

Ginger V. Martin
Mother/Manager
mother.nature08@yahoo.com
204 South Prairie Lane
Georgetown, TX 78633
661.342.6799

Rosemary McDowell APM.APMP / p.69
Rosemary McDowell International

I am a business strategist, bestselling author, speaker, Beltway NavigatorTM, Virtual ChairwomanTM."Business is about Building Relationships…and Building Relationships is our Business!

www.rosemarymcdowell.com
RMcDowell@rosemarymcdowell.com
Fairfax, VA
571.295.5850
571.214.1282

Kimbra Ness / p.70
Gigi and Me Children's Books
Kimbra Ness Global Real Estate
Keller Williams, Lake Minnetonka

I am an author, writer, poet, professional speaker, philanthropist, business owner and cancer survivor. My mission is to educate, encourage, embrace and empower our individual legacy. "No one can go back and start a new beginning, but we all can start today and make a new ending."

www.kimbraness.com
www.gigiandmebooks.com
www.kimbraness.kwrealty.com

Shelley Harper / p.72
Lead MetalSmith & Owner
Accessoreez.com

www.facebook.com/ShelleyHarper
sharper522@aol.com

Leslie Belcher-Huston / p.72
Lead Artist & Owner: Accessoreez.com

Accessoreez is your source for one of a kind, hand blown glass jewelry. My sister and I create the Fearless Women/Sacred Gems jewelry with Mary Ann Halpin, where a portion of all sales goes to fund the non-profit, A Billion Fearless Women.

www.facebook.com/LeslieBelcher
www.twitter.com/accessoreez
www.facebook.com/Accessoreez
1005 25th Avenue N.
Saint Petersburg, FL 33704

Linda Gabriel / p.75
I am a Visionholder, Thought Whisperer, holistic coach, author, and motivational speaker

www.lindagabriel.com
www.thoughtmedicine.com
www.diet4yourmind.com
www. visionholders.com
MSLGABRIEL@gmail.com

Rose Pagonis / p.76
The GDV Foundation

I am founder of the GDV Foundation (The George & Dimitra Vlahos Foundation), passionately bringing awareness and philanthropy to families affected by Alzheimer's Disease. "Memories are embedded in the soul!"

www.GDVFoundation.org
rose@gdvfoundation.org
Naperville, IL
630.248.5475

Marcia Wieder / p.79

I am the CEO/Founder, Dream University® and Spokesperson for the Million Dreams™ Campaign. I am committed to helping one million dreams come true by providing tools and training for clarity, courage and confidence. As the author of 14 books, I serve on the Advisory Board for the Make A Wish Foundation, and love exotic travel.

www.DreamUniversity.com
www.MillionDreamsCampaign.com
Marcia@DreamUniversity.com
800.869.9881

Pamela G. Alexander / p.83
Minnesota Council on Crime and Justice

I am the Executive Director of the Council, Retired District Court Judge, Law Professor, motivational speaker and mentor.

www.crimeandjustice.org
alexanderp@crimeandjustice.org
822 South 3rd Street, Suite 100
Minneapolis, MN 55415
612.353.3000

Linda Rivero / p.84
Creating Connections Across Boundaries and Borders

I am a social entrepreneur, speaker, traveler, writer and musician. Founder and CEO of the Global Action Network of Entrepreneurial Women: Connecting, Supporting and Engaging Social Entrepreneurs Worldwide for the Evolution and Empowerment of Women, Everywhere.

www.LindaRivero.com
lrivero@LindaRivero.com
Washington, D.C.
703.835.9378

Nicole Jackson Jones / p.86

I am a writer, author, comedian blogger, owner of Twisted Broad, a website dedicated to getting humorous tales and sexy tips out into mainstream media for those adults tired of Cosmo and GQ.

www.twistedbroad.com
www.youtube.com/twistedbroad
www.twitter.com/twistedbroad
www.facebook.com/twistedbroad
info@twistedbroad.com

Paige Bearce-Beery / p.89

I am a successful entrepreneur, international business owner, leader, caregiver, and creative chef.

www.heavyeq.com
www.americantransitsupply.com
www.liveatchoice.com
paige@heavyeq.com
Oakland, CA 94619
510.531.7240

Lisa Larter / p.91
Lisa Larter Group

I am a writer, speaker, entrepreneur and Social Media advisor with a passion for business, inspiring people and simplifying technology.

Connect with me on Twitter @LisaLarter
www.LisaLarter.com
www.ParlezWireless.com
lisa@lisalarter.com
775 Taylor Creek Drive,
Ottawa, ON K1C1T1

Linda Hollander / p.93
Wealthy Bag Lady/Sponsor Concierge
Business and Sponsorship Success
www.WealthyBagLady.com
www.SponsorConcierge.com
Linda@WealthyBagLady.com
13428 Maxella Avenue, Suite 982
Marina Del Rey, CA 90292
310.337.1430

Naomi Ackerman / p.94

I am a wife, mother, activist, writer, performing artist/ actor, educator, andn Founder and Executive Director of The Advot (Ripples) Project, a registered 501(c)(3) corporation that uses theatre for social change.

"Be the change you want to see in the world."
Mahatma Gandhi

"Let the dignity of other people be as important to you as your own" Pirki Avot

Ackerman.naomi@gmail.com
www.naomiackerman.com
www.theadvotproject.org

Rebecca Gray Grossman / p.97
The Grossman Burn Foundation

www.grossmanburnfoundation.org
Rebecca@grossmanburnfoundation.org

Lorelei Wolter Kraft / p.98

I am an author, speaker, producer and consultant, author of "Anything Is Possible!" and "Letting Go of Mommy Guilt," a "Million Dollar Mama"—member of the exclusive club of only 1.8% of women business owners who reach revenues of a million dollars.

- Minnesota Woman Business Owner of the Year
- Recipient of the Governors' Entrepreneurship Award
- National Association of Women Business Owners "Vision Award"

www.loreleikraft.com
Park Rapids, MN 56470
888.510.4424

Mary Jo Sherwood / p.101
Sherwood Concepts, LLC

I am an author, speaker, consultant, professional connector, and Founder of Fire of Hope

www.SherwoodConcepts.com
www.FireOf HopeUSA.com
maryjo@sherwoodconcepts.com
Eden Prairie, MN
612.669.0450

Mona Polacca, M.S.W. / p.102
Havasupai, Hopi and Tewa Native American

I am a Human Services Consultant committed to supporting initiatives that involve developing effective strategies, sensitive approaches and action addressing indigenous human rights, and I work towards improving the quality of life of global indigenous peoples. I am a founding member of the International Council of Thirteen Indigenous Grandmothers, and am involved in planning the Indigenous World Forum on Water and Peace.

www.grandmothercouncil.org
gmc.monap@gmail.com
Scottsdale, AZ

Maryse Senecal
Target Your Health / p.104

I am an orthotherapist, a nutritional counselor and a personal trainer. My mission is to empower women in finding their true strength through health and vitality by creating on-line power circles across the world.

www.myoprecision.com
http://myoprecision.com/power-circle.html
maryse@myoprecision.com
Ottawa, Ontario Canada
613.794.7009

The Mommy Docs / p.107

We are Obstetrician Gynecologists who actively practice in Los Angeles. We are founders of the Mommy Docs Foundation which was developed with the mission to deliver health care to uninsured women in Los Angeles. Our goal is also to educate women about pregnancy and all aspects of women's health via our television program "Mommy Doc's," through our book, The Mommy Docs' Ultimate Guide to Pregnancy and Birth, and via our website, Mommy Docs.

Individually: Yvonne Bohn, M.D.,
Allison Hill, M.D., and Alane Park M.D.
info@mommydocs.com
637 South Lucas Suite 200
Los Angeles, CA 90064
213.977.4190

Marsha Mercant / p.108

I am an actor, singer, voice-over talent, writer, editor, producer...more yet to be discovered! As an editor, I help writers and speakers focus their message, clarify their voice and increase their accessibility, thus reaching a wider group in the most effective and impactful way. My mission is to be the best me I can be and hold the space for others to be that as well.

www.marshamercant.com
mashmercant@gmail.com

FEARLESS SPONSORS

Thank you to our Fearless Sponsors for your generous contributions to this project.
We are Fearlessly Grateful!

Advot is Hebrew for ripples

www.chantelle.com

www.centerforautism.com

www.koreyhowell.com

AMERICAN TRANSIT SUPPLY

www.amprocon.com

www.jizopeacecenter.org

www.sponsorconcierge.com

www.6thofmay.org

www.wealthybaglady.com

What you need. When you need it...

www.amprocon.com

thehotelcard.com

Grossman Burn Foundation

www.grossmanburnfoundation.org

www.fireflyledlight.com

ABOUT FEARLESS WOMEN™ GLOBAL

The Fearless Women movement and organization were inspired by the HH Dalai Lama who in 2009 declared, "The world will be saved by the western woman." Fearless Women Global founder and visionary photographer, Mary Ann Halpin took this to heart, gathering women with the wisdom, dynamism and vision to lead the way. One of her first steps was to create a book series titled Fearless Women. Events in twelve major U.S. cities followed.

A global visionary movement, Fearless Women fosters women who make a difference in the world by overcoming their own fear with courage and uplifting others with love. Inspiring growth and transformation of themselves and others, Fearless Women builds self-direction, confidence and connections.

At the helm is Fearless Women Global, an international company with a mission to inspire, motivate, educate and connect women leaders, business owners, and community members. Members form enduring connections through its membership program, events, products, services and non-profit activities.

In addition, the sister non-profit organization, A Billion Fearless Women, aims to bring a billion women together globally to generate and support charitable projects that create a more compassionate, equitable and healthy world. One such project is Miracle Village in Ki-Mombasa, Uganda, where a new community with educational and health care facilities is being built for women and children living in extreme poverty and fear.

Fearless Women Global and its partners are a sisterhood of women who are stronger together than on their own as they support, honor and stand for each other in our challenged world.

For more information, visit:

www.fearlesswomenglobal.com

www.abillionfearlesswomen.org.

Follow us on:

Facebook: www.facebook.com/fearlesswomen

Twitter: @FearlessWomenUS

INNER STAR

Chris Bennett - Singer/Songwriter

Grammy-nominated singer/songwriter/pianist **CHRIS BENNETT** began touring the world and met Giorgio Moroder in Germany who chose her as the lead singer of his new group, *Munich Machine*. Her first CD, Munich Machine, Introducing Chris Bennett, produced several hit dance singles including *Whiter Shade of Pale* and *Love Fever*. She recorded a duo album with Moroder, *Love's in You– Love's in Me*, and co-wrote the *Theme from Midnight Express* with Moroder, which received a Grammy nomination. She began writing songs for stars like Tina Turner, Keb Mo, The Three Degrees and The Manhattan Transfer and co-wrote Suzi Lane's hit *OOH LA LA* with Moroder.

Publisher: *Only Daughter Music*

Website: www.chrisbennett.com
Email: chrisb@chrisbennett.com

Vincenza "Vinny" Scrima - Songwriter

Vincenza "Vinny" Scrima, was born in Boston and was playing in local bands in his teens. His talent as a bass player and composer landed him a coveted spot at Berkeley School of Music where he graduated with honors. After college Vin and his brother, drummer Joey Scrima, headed to LA to get in the music business. Vinny found success playing with stars like Connie Stevens, Chicago, Tower of Power, and many more. His arrangements were featured on *The Tonight Show*. He met co-writer, Chris Bennett, on a tour of Japan and has produced and arranged songs on several of her CDs.

He lives in Los Angeles where he is active as a songwriter, producer/arranger and bass player.

I AM A GIFT

Karen Drucker - Singer/Songwriter Co-Writer: Karen Taylor-Good

Karen Drucker has recorded 14 CDs of original positive-message music and an inspirational book; "Let Go of the Shore." She sings, speaks and leads workshops at women's retreats, churches, conferences, and presents with well-known authors in the self-help field. She started her own organization, "Artists For A Cause," to raise awareness and funds for organizations in need by producing concerts. For her musical contribution to New Thought music, she was awarded an Honorary Doctorate by UCSL. Karen has been called "a master of communicating presence and spirituality through music." She loves making music, making a difference, and touching hearts.

Publisher: *TayToones Music-BMI*

Website: www.karendrucker.com

HAPPINESS

Sherry Williams - Singer/Performer/Co-writer

Sherry sang and toured with The Young Americans, worked with the famous Roger Wagner and the UCLA Choir, both in Los Angeles and Europe. Sherry joined The Unusual We in 1969. Sherry has had numerous television appearances on shows such as *The Tonight Show with Johnny Carson*, *The Glen Campbell Show*, *The Tom Jones Show*, *The Della Reese Show*, *Soul Train*, and recording sessions including albums with El Chicano and Red Bone . She has also toured with Andy Gibb, the legendary Johnnie Ray, and The Eddie Kendricks Tour. In 1997, she released her first CD, "The Way You Love Me." Her second release, A Taste Of Sherry, was on the 2003 Grammy ballot and one of the songs was used in the soundtrack of the film The Core. In late 2003 she released "You Must Believe In Spring."

Website: www.sherrywilliamsmusic.com

Donna Fein - Songwriter

Singer/Songwriter and LA Studio veteran, Donna Fein has more than 25 years of professional experience in the Music, Commercial, Radio, Television, Theatre and Film industries. Donna has performed with such notable artists as Barry Manilow, Olivia Newton-John.

As a two-time cancer survivor Donna has counseled cancer patients for the last 15 years, supplying tips and information of how to keep a sense of humor in the midst of the chaos. She played an active role on the Advisory Board of Be Empowered, Inc., a not-for-profit organization providing resource information to adults newly diagnosed with cancer.

In 2009, Donna recorded 'Takin' Chances', a selection of story-songs to soothe your soul, lift your spirit, and touch your heart. Donna contributed her song "Eyes Of A Child" for MaryAnn's Video documentary "Spirit of America" "I'm honored and blessed to be asked, and I am grateful"…

Publisher: *DDBGood Music*

Email: dlfein@sbcglobal.net

Takin' Chances

DONNA FEIN

HANDS

Karen Taylor-Good - Singer/Songwriter

Nominated for a Grammy for her song "How Can I Help You Say Goodbye" and holds the distinction of the 2-time SESAC Songwriter of the Year. She has sung on recordings and movie soundtracks with Dolly Parton, Willie Nelson, Elvis and many others. Her songs have been recorded by Melissa Manchester, Al Jarreau, Patty Loveless, Collin Raye, Diamond Rio, etc, etc. Many of her songs have been chosen to be "Flagship" songs for organizations like The Compassionate Friends, Childhelp USA, and the National Hospice Foundation. As the "Song Guru" she is dedicated to making a difference in the world with her music.

Publisher: *Song Guru Music*

Website: www.karentaylorgood.com

BE THE CHANGE

Gypsy Soul Cilette Swann and Roman Morykit - Singer/Songwriters

People Magazine says, "Transcendent. Her voice is haunting and his musicianship is superb. Their music stirs the soul and moves the spirit."

Cilette Swann traveled to Europe chasing her Celtic roots. Her quest took her to Scotland where she met world-class musician and producer, Roman Morykit. These esteemed performers have sold over 120,000 CDs independently with 1.5 million downloads. The Duo's music has aired many times in films and TV shows including: Providence, Felicity and Roswell. They've had a Top 40 A/C radio hit and most recently, songs aired throughout Europe.

Publisher: *Off The Beaten Track Songs* (ASCAP) and *Pensive Music* (ASCAP)

Website: www.gypsysoul.com
Email: band@gypsysoul.com

TRUST THE WIND

Marsha Mercant - Singer

Marsha Mercant has performed on stage internationally as well as on TV and in film. Her many voice-overs can be heard on TV, radio and your telephone! For more information, go to www.marshamercant.com

Website: www.ppirecording.com

David Friedman - Songwriter

Best known for his songs of inspiration, David's songs have been recorded by artists as diverse as Nancy LaMott, Diana Ross, Barry Manilow and Alison Krauss. David has conducted 5 shows on Broadway, and his film credits include conducting/vocal arranging for Disney's Beauty & The Beast, Aladdin, Pocahontas & Hunchback, and songwriting for The Lizzie McGuire Movie, Bambi II, Aladdin & The King of Thieves, Trick and many others. David appears regularly as a songwriter on the Today Show, has 5 new musicals in the works, and recently published a best selling book, The Thought Exchange®-Overcoming Our Resistance to Living a SENSATIONAL Life.

Learn more at: www.middermusic.com
or: TheThoughtExchange.com

Publisher: *Midder Music*

Accompanist: Doyle Newmyer

Recorded at P.P.I. RECORDING, INC.
New York City, NY
Chip Fabrizi

VISIONS OF A NEW WORLD

Sarah-Jane (SunJay) Owen - Songwriter

Silver Album and international award winning singer songwriter and musician with UK all girl band The Belle Stars. Hope Los Angeles Musical Enrichment Educational Program Kern Arts Council Award for musical and artistic achievement. Certified Sacred Sound Healer, Shamanic Practitioner. Village Drum Circle Facilitator and Yoga Instructor. SunJay offers and performs a wide variety of unique programs - beautiful healing ceremonies that speak to our heart and nurture the soul.

Engineered by: Charlie Hall
Arrangement by: Charlie Hall and Sarah-Jane Owen
Performed by: Perfect 5th
Publisher: *SunJay's Music Medicine*

Website: www.powwowlodge.com
Email: sunjay@powwowlodge.com
Pine Mountain, CA 93222

Ginger Martin - Manager of The Perfect 5th.

I am the mother/manager of the 5 sister singing group, Perfect 5th. Perfect 5th is on a mission to aspire and influence positive change in the world through uplifting songs that will ignite and empower people to participate in a changing world.

Email: mother.nature08@yahoo.com
661-342-6799
Ginger Martin
204 South Prairie Lane
Georgetown, TX 78633

COMMON PLACES

Starr Parodi - Songwriter

Pianist Starr Parodi's first big break came as the talented, funky, multi-keyboardist who appeared nightly on the groundbreaking late night hit, "The Arsenio Hall Show". The critically acclaimed composer and pianist has returned to her touchstone and first love, the piano for an intimate solo recording of spontaneous and uncommon improvisations on themes entitled "Common Places: piano improvisations" On "Common Places", Starr draws inspiration from her 1928 Steinway grand piano that once adorned the legendary MGM sound stage in its most glorious era and was used on such classic films as "The Wizard Of Oz". "Common Places" has been selected as Solo Piano Record Of The Year by solopianoradio.com, and echoes with cinematic, neoclassical, americana and gospel themes all played as "stream of consciousness" improvisations. "I recorded this music purely out of joy, purely out of sorrow, purely out of longing and a searching, a peacefulness and a restlessness", she says. "these are the common places we all share." my "Common Places is avail for purchase through iTunes, Amazon, CD Baby and parodifair.com."

Publisher: *Esque Music* (BMI)

Website: www.parodifair.com
Email: commonplaces@earthlink.net

SOPHIA

Stephanie Quayle - Singer/Songwriter

Singer Songwriter Stephanie Quayle been referred to as a Cause Cowgirl, an Architect of Change, on the frontier of bridging the Country music world to global recognition through her voice and humanitarian efforts. Stephanie Quayle has taken songwriting and performing to the world's stage with an authentic edge and her heart wide open. Through her music and her message Stephanie is inspiring a positive epidemic of "Can Do's" and perseverant attitudes. Stephanie has experienced and endured more than most young women her age but all the hurdles and challenges have continued to strengthen her drive toward success.

Publisher: *Stephanie Quayle*

Website: www.stephaniequayle.com

WOMEN OF TODAY

Faith Rivera & Beth Eichel - Songwriters
Performed by: **Faith Rivera**

Faith Rivera is an Emmy-winning singer, songwriter & positive music artist. Her empowering music has been featured all over the globe from popular TV shows to peace events in Tokyo to St. Croix. She's worked with best-selling authors like Marianne Williamson & Jack Canfield, sung with Luther Vandross to Neil Young, and wowed audiences from the Hollywood Bowl to the Honolulu Symphony. Originally from Hawaii, Faith now lives in Long Beach, California with her high-school sweetheart Nolan Hee & baby boy, Kai.

Publisher: *Lil' Girl Creations*

Website: www.faithrivera.com

(THE GIRL WHO) CHANGED THE WORLD

Sister - Singers/Songwriters

"Sister" is three, real - life sisters from Minneapolis producing and performing original music. "The Girl Who Changed the World" is a cut from their latest release "There Goes My Heart". This collection of music is designed to inspire, support and energize women and girls as they seek to bring their original lives to the party! Dream, create and be the designer you already are -- and, as always, call your Sister -- she can help!

Written by Kara Millerhagen and Alisa Leonard

Publisher: *Sister Productions*
Copyright 2010 Sister Productions

Website: www.SisterProductions.com
Also on Facebook and You Tube

TOPANGA DREAMS

Suzanne Teng - Songwriter

Suzanne Teng is a flutist, composer and recording artist whose music can be heard on film and television soundtracks as well as hundreds of recordings. With her husband and music partner Gilbert Levy, they travel the world with their world music band Mystic Journey.

Their recordings have won numerous awards including the Independent Music

Awards, Los Angeles Music Awards and International Acoustic Music Awards. Their music is recognized for its healing and transformative qualities and was selected by the pharmaceutical company Genentech to distribute to over 50,000 cancer patients to aid in their recovery.

Song written by: Suzanne Teng
Owner: Suzanne Teng

Publisher: *Weishiu Music* (ASCAP)

Website: www.suzanneteng.com

FREEDOM

Yeh Dede

Yeh Dede is an all women world music fusion ensemble based in Los Angeles, and is dedicated to making the world smaller and more understood one song at a time. Delving into music of West Africa, the Middle East, Afro-Cuban songs and their own musical creations and improvised interpretations, Yeh Dede encompasses a full spectrum of the human spirit, voice and potential. Yeh Dede's mix of Afro-Latin percussion with sultry and sometimes sensual voices "nurtures their listeners global conscious and instills in them an overwhelming urge to put their body to the dance." Yeh Dede means "to make sound" in Twi, a language from Ghana.

Written by: Tom Benjamin, additional lyrics by Suzee Waters Benjamin
Arrangement: Mari Oxenberg & Yeh Dede

Publisher: *Branch Creek Music* (ASCAP)

Website: www.yehdede.com

"Ignite the calling in your heart...

Embrace your sword of courage...

Move through your fear to your vision...

Empower your life...

Transform the world!"

And the fearless journey continues...